PAUL NICKLEN POLAR OBSESSION

POLAR OBSESSION

PAUL NICKLEN

FOCAL POINT

NATIONAL GEOGRAPHIC
WASHINGTON, D.C.

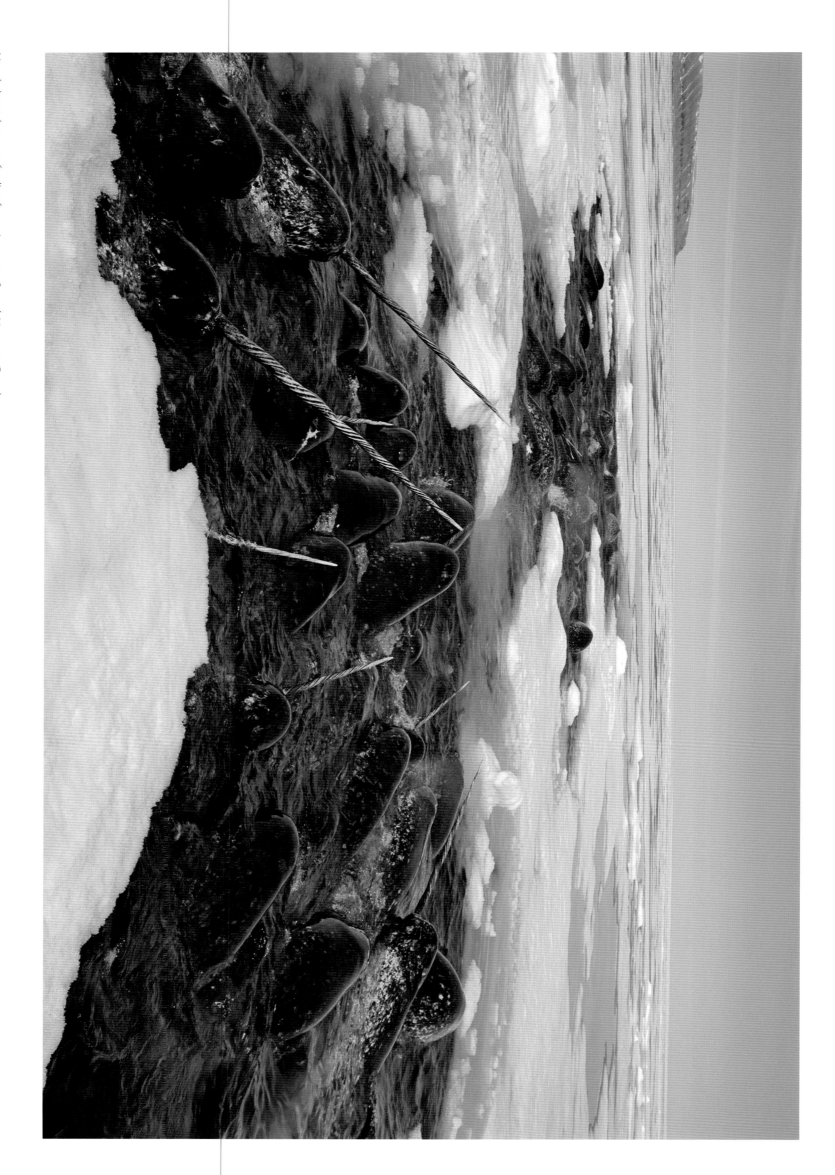

Narwhals rest between feeding forays, Lancaster Sound, Nunavut, Canada.
Following pages: Dimpled glacier ice formed by currents, Svalbard, Norway.

We need another and a wiser and perhaps a more mystical concept of animals. Remote from universal nature, and living by complicated artifice, man in civilization surveys the creature through the glass of his knowledge and sees thereby a feather magnified and the whole image in distortion. We patronize them for their incompleteness, for their tragic fate of having taken form so far below ourselves. And therein we err, and greatly err. For the animal shall not be measured by man. In a world older and more complete than ours they move finished and complete, gifted with extensions of the senses we have lost or never attained, living by voices we shall never hear. They are not brethren, they are not underlings; they are other nations, caught with ourselves in the net of life and time, fellow prisoners of the splendour and travail of the earth.

Henry Beston
The Outermost House

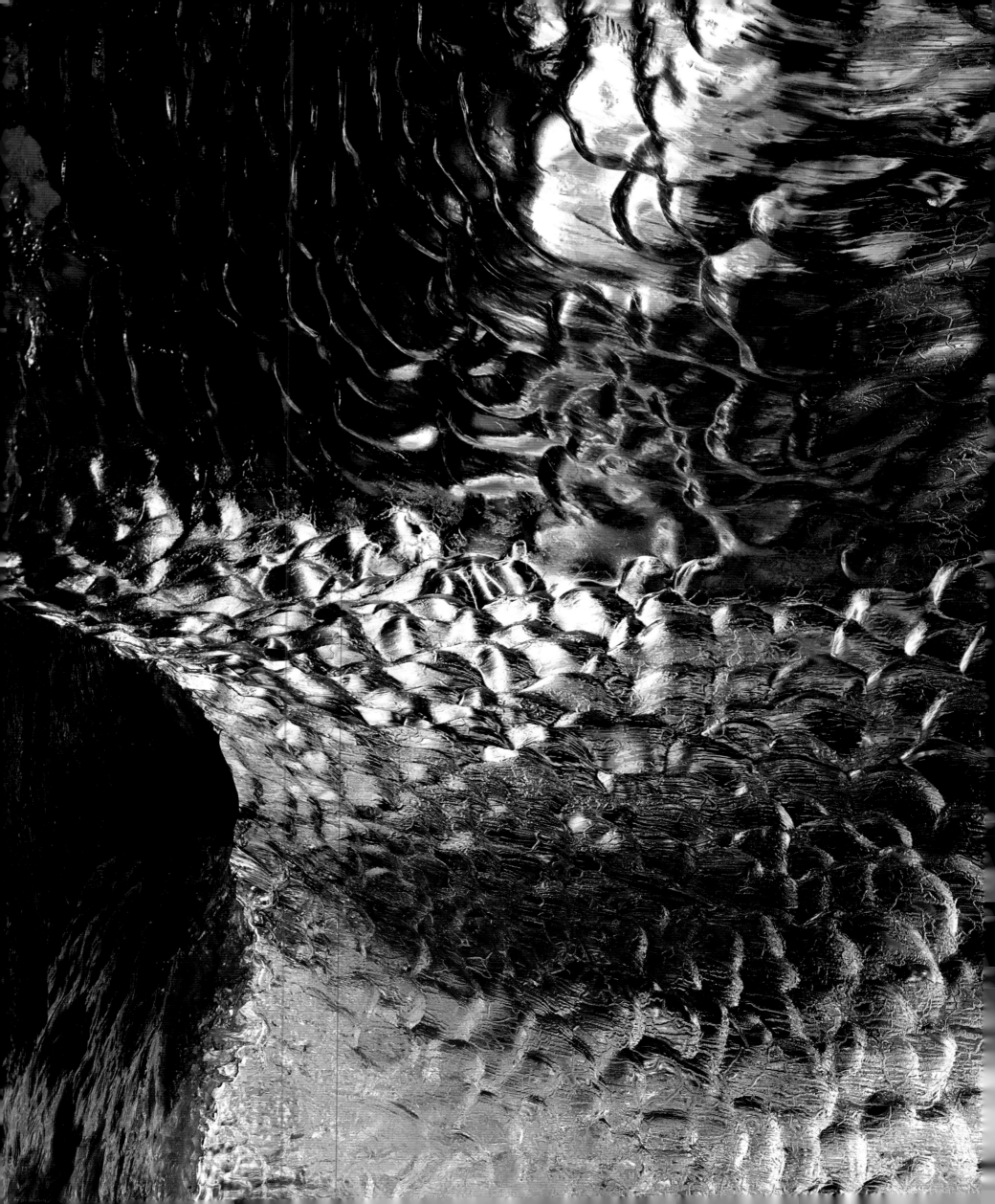

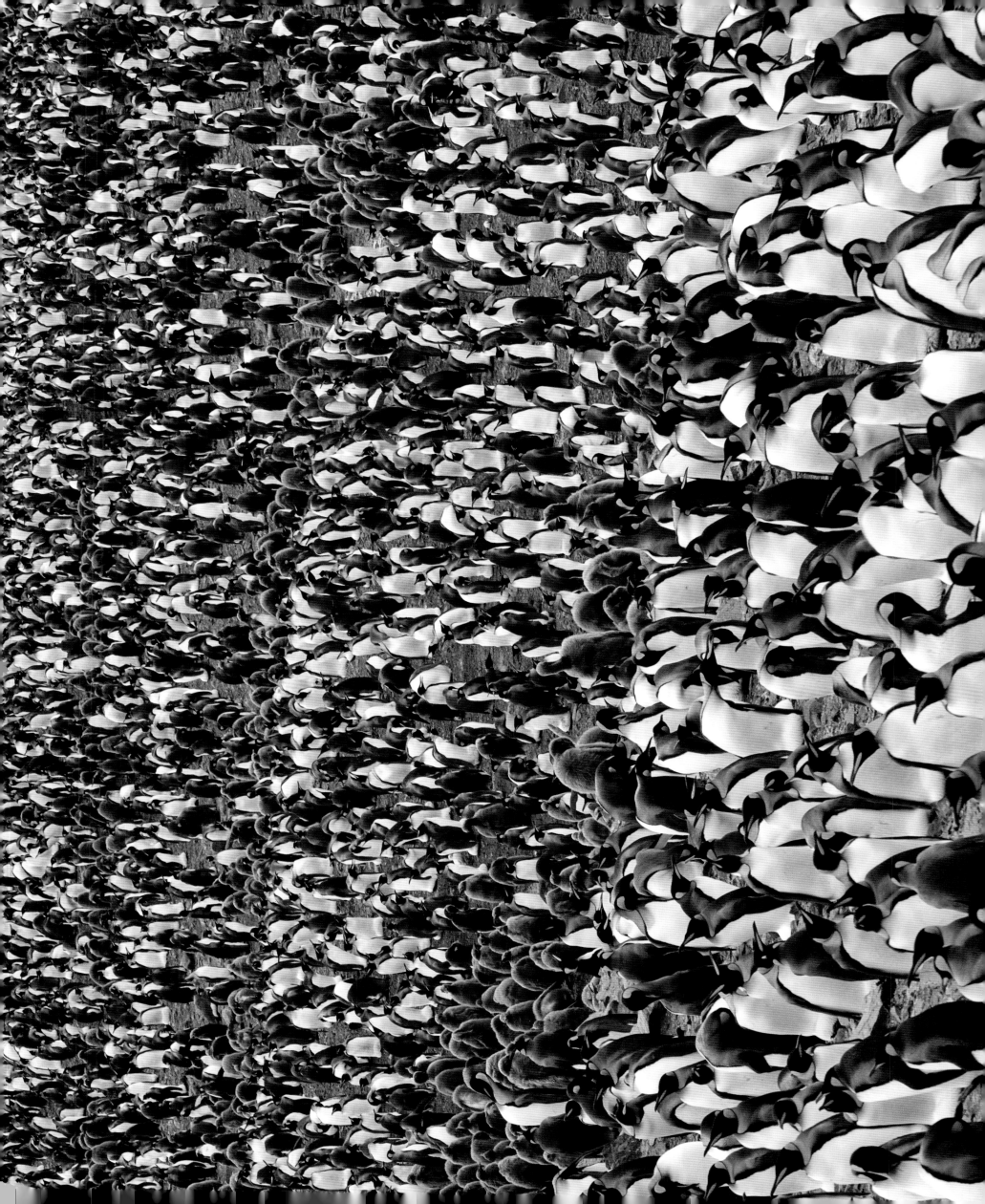

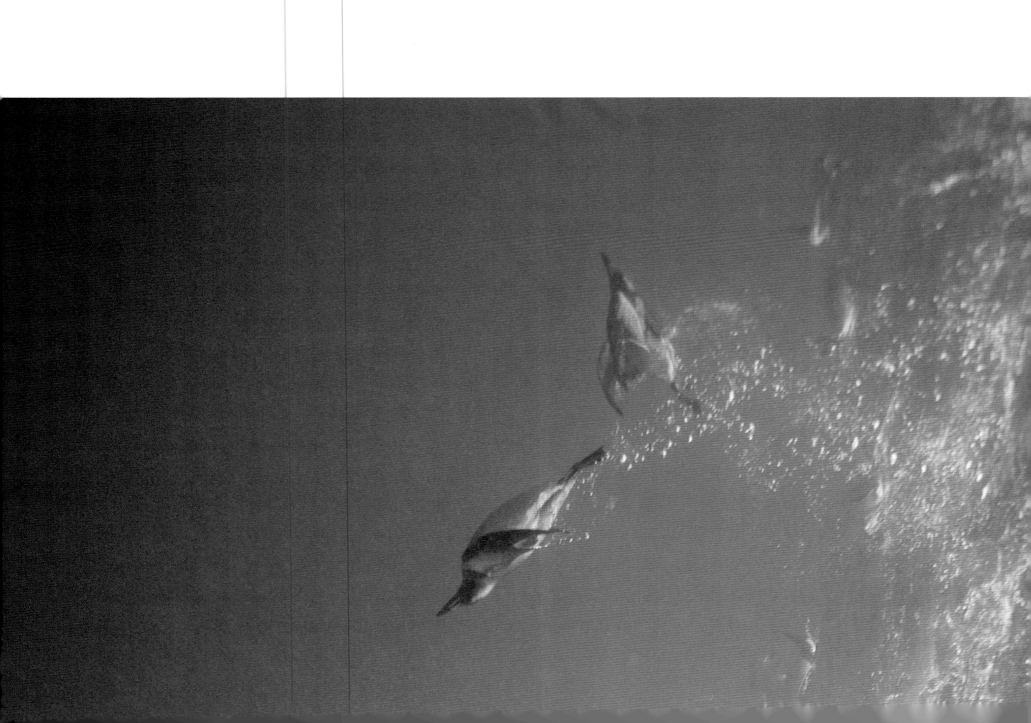

Brünnich's guillemots dive to feed on fish, Bjørnøya, Svalbard, Norway.

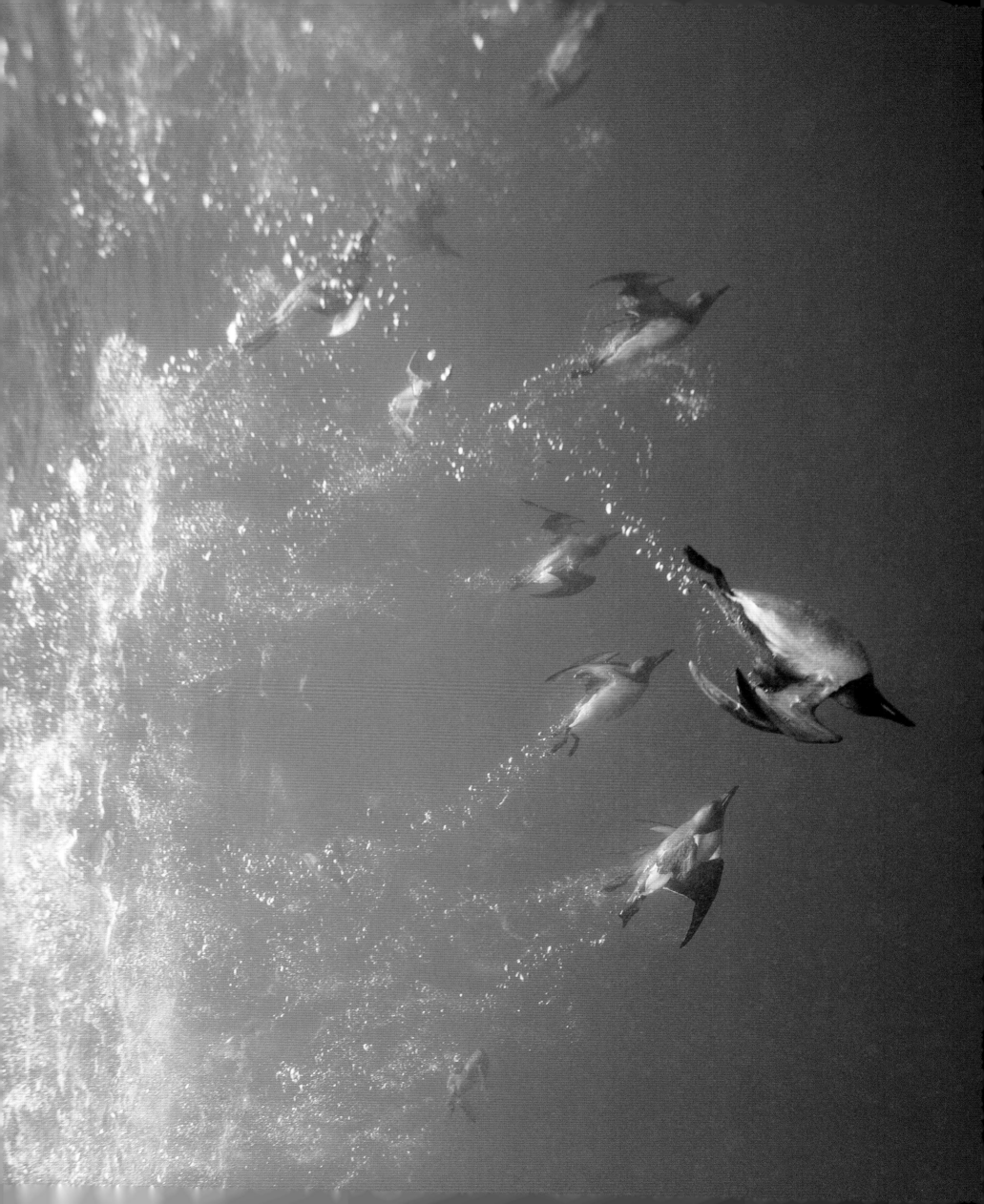

A leopard seal feeds me a penguin, Antarctic Peninsula.

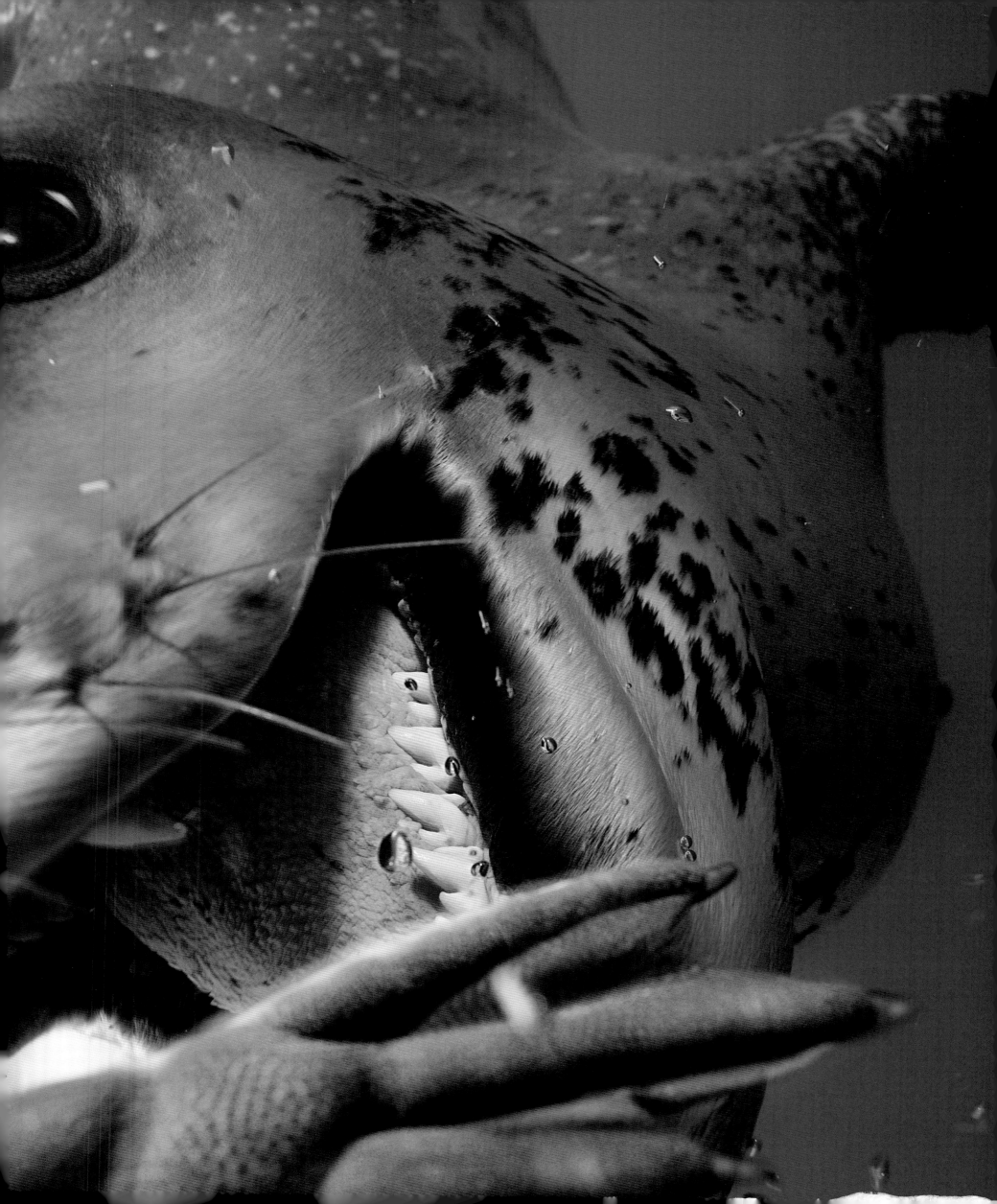

LEGEND

Minimum Sea Ice Extent

September 2008

September 1988

Other Features

International Boundary

Selected Maritime Treaty Boundary

N O R T H A M E R I C A

C A N A D A

Longitude West of Greenwich

Hudson Bay

Labrador Sea

Davis Strait

Baffin Bay

Baffin Island

GREENLAND (Denmark)

Ellesmere Island (Canada)

Axel Heiberg Island (Canada)

Prince Patrick Island (Canada)

Banks Island (Canada)

Beaufort Sea

ARCTIC CIRCLE

ALASKA (United States)

Chukchi Sea

Wrangel I. (Russia)

New Siberian Islands (Russia)

East Siberian Sea

Laptev Sea

North Land (Russia)

North Pole

North Magnetic Pole 2009

A R C T I C O C E A N

Franz Josef Land (Russia)

Svalbard (Norway)

Barents Sea

Kara Sea

Novaya Zemlya (Russia)

Greenland Sea

Norwegian Sea

NORWAY

Meridian of Greenwich

Iceland

A T L A N T I C O C E A N

E U R O P E

ARCTIC CIRCLE

R U S S I A

S I B E R I A

Sea of Okhotsk

Bering Sea

International Date Line

Sunday Monday

P A C I F I C O C E A N

Longitude East of Greenwich

0

200

400

800

1200

STATUTE MILES

0

200

400

800

1200

KILOMETERS

Azimuthal Equidistant Projection

Antarctic map at same scale is located on page 152.

Arctic

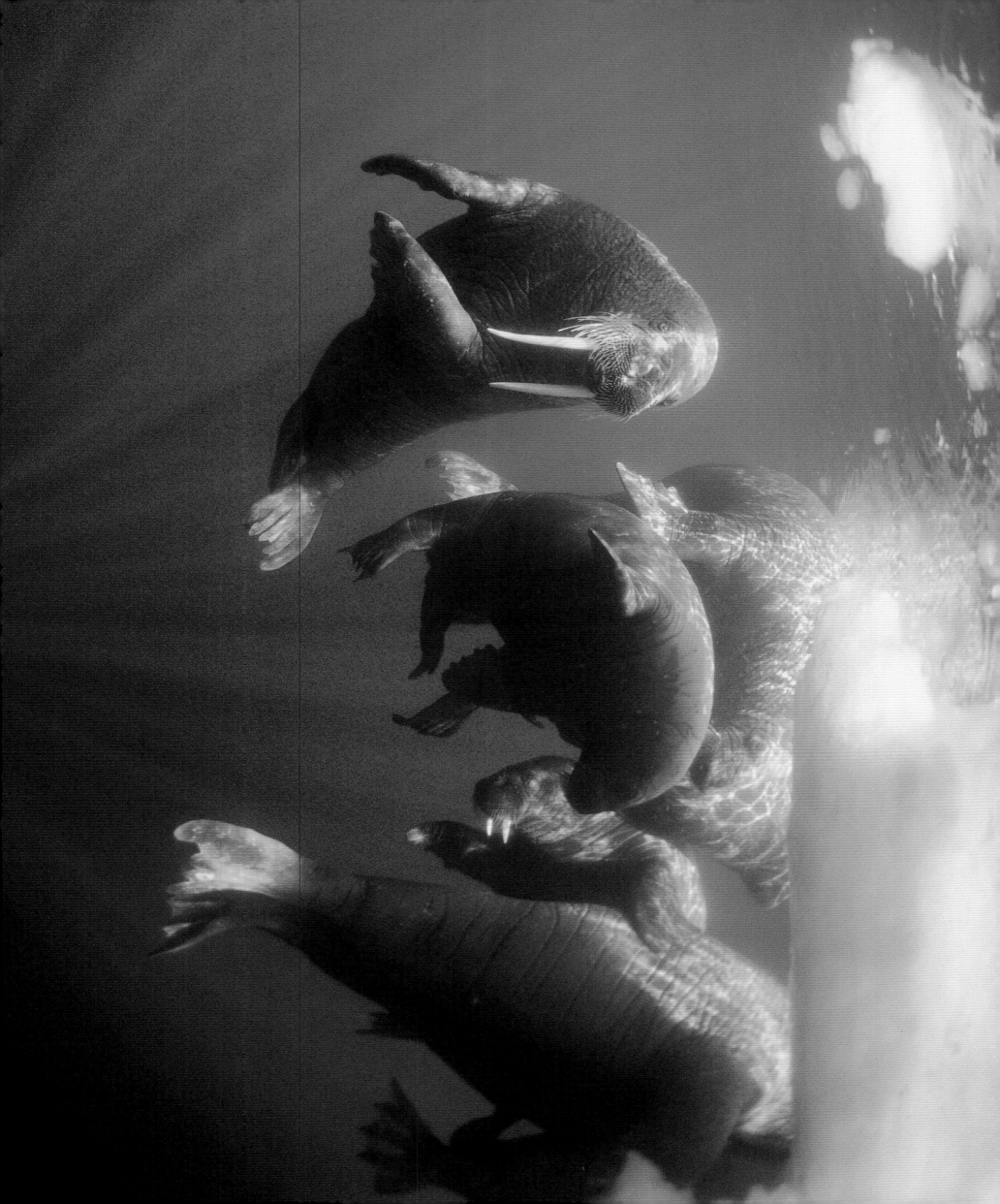

Ice and the Cycle of Life

The frigid water hit my face and neoprene-clad head so hard I thought I would vomit into my regulator. I began my descent through the slushy water and clenched my teeth around the mouthpiece, fighting back the nausea. Soon my breathing slowed and my head became numb with cold; I exhaled slowly, allowing myself to dive farther down through the crack in the sea ice into the abyssal blackness. At one point I looked back up at the ice, expecting it to appear as it most often does this early in the season— blue, featureless, and lifeless. But something wasn't right.

On this cold afternoon in May, I had slipped through a narrow crack between the wide sheets of sea ice in order to observe and, I hoped, photograph the creatures that call these icy depths their home. With my Inuit guide, Gideon Qaunaq, and my assistant, Jed Weingarten, I was about 16 kilometers (10 miles) south of Lancaster Sound, off the northern tip of Baffin Island in the Canadian Arctic. The water was an excruciating −1.5°C (29°F)—as cold as seawater can get before it freezes solid.

Looking up at the thick sheet of ice between the surface and me, I struggled to make sense of what I was seeing. The ice was stained green and brown, and the whole underside of the ice sheet appeared to be moving. I blinked and checked my depth. I wanted to be sure I wasn't suffering from vertigo, which can be deadly to a diver working alone under a three-foot roof of ice.

Then it hit me: I wasn't seeing ice at all. I was watching millions of amphipods, tiny shrimp-like crustaceans, feeding on the phytoplankton that grow on the underside of the ice in spring. In all my years of diving in Arctic waters, I had never witnessed such a plethora of life under the sea ice. Every year, the long, dark Arctic winter gives way to the warming rays of sun that renew life through the process of photosynthesis, creating plant life on the underside of the ice and restarting the cycle that sustains Arctic creatures for yet another season. As blizzards continue to rage across the surface and temperatures still reach deep lows, life on the underside is consistent, calm, and rich.

I squeezed my eyes shut and slowly opened them, allowing myself to adjust to the dark world under the ice. Moments before, I had been standing on the surface in a white world, with cold temperatures and strong winds. Only a few feet below that position, I had descended into an icy liquid realm where the life cycles of breeding and feeding zooplankton clinging to sea ice had begun much earlier than I expected. I was looking at the very

< Atlantic walruses congregate under multiyear ice, Foxe Basin, Nunavut, Canada.

foundation of the Arctic ecosystem, the tiny life-forms that start off the food chain and upon which all the bigger animals—polar bears, whales, birds, and seals—depend for sustenance. The larger creatures' life cycles and migratory patterns position them in the right place at the right time to feed on the lower trophic layers of the ocean's bounty; like all parts of the complex cycle, the tiny creatures need to mature on a certain schedule.

I have lived in the Canadian North since I can remember, and I've spent most of my career photographing all of the creatures in this polar region. When I began working as an underwater photographer, sea ice seemed invulnerable; even in the warmest months much of the ice remained. The idea of an Arctic without ice was unimaginable then. Each spring, massive bowhead whales arrived like squadrons of submarines to feed on amphipods and copepods. Joining them were masses of beluga whales and narwhals chasing Arctic cod. Ringed and harp seals also fed on Arctic cod as they tried to hide from seals in the layers of multiyear ice. As the polar bears roamed the ice hunting for food, the ringed seals relied on the shelter provided by fissures and cracks in the sea ice, where they lived under snowdrifts throughout the harsh winter months. Here, in their protected seal lairs, their world remained sheltered from the elements, allowing them time and space to give birth and nurture their young until the spring. This is when polar bears uncover some of the lairs and feast on fat baby seals, which provide the bulk of the bears' weight gain each year.

Some ten years after the start of my photography career, things have changed. The vast expanses of sea ice are greatly diminished, and in some areas they are gone altogether. We know that the Poles are melting at an unprecedented rate and that, as global warming grinds on, the possibility of an ice-free Arctic creeps closer each day. Scientific models predicted that the entire Arctic pack would disappear in the next 50 to 100 years. The skeptics complained that we could not believe in these models. In fact, the scientists were terribly wrong in their projections, and the Arctic could be free of summertime ice in the next 7 to 20 years, which will have catastrophic effects on the myriad species that rely on a healthy ecosystem.

The photographs in this chapter represent a decade's work on the ice. They embody my love of ice and the blue-white rich marine world it nourishes. As a wildlife photojournalist, it is my hope that these photographs also carry a message, one that I understood with profound clarity that May

day as I watched amphipods flit along the underside of the ice and listened to the clicks and squeals of approaching whales. I feel it can never be said too often that if global temperatures continue to rise, the ice will likely disappear, and an Arctic without ice would severely alter the balance of the polar ecosystem.

This ecosystem contains an astonishing array of creatures, from the tiniest phytoplankton to the massive and elusive bowhead whales. Before I began work as a photographer, the bowhead was the species that I most dreamed of capturing on film. At more than 100 tons, they are the second heaviest whales in the world, next to the blue whale. Much of their weight can be attributed to a blubber layer up to a foot thick that allows them to live year-round in the polar seas. In the Eastern Arctic they were hunted nearly to extinction and have been slow to recover. Bowhead whales skip all trophic levels and feed directly on amphipods and copepods, whose oily bodies make them nutritionally the richest organism in the world.

Beginning in my mid-twenties, I wanted my photography to reveal connections between the different elements of the Arctic ecosystem. At that time, with limited financial resources, I flew to a tiny island called Igloolik near the northwest corner of Baffin Island and concentrated on the bowhead whales. I arrived in June, and pitched my tent alongside that of my guide, just beyond where the Inuit walrus hunters were camped on the beach. There I waited for the right conditions; only then would I be able to go in search of the whales, which would arrive from the south through Foxe Basin and from the north through Fury and Hecla Strait. I sat in my small tent, waiting out one storm after another, with winds that drove loose ice tight against the southern shores of Igloolik. On the rare days when the wind let up, the pack ice prevented us from going out to look for whales. I lived on walrus and seal meat that the hunters kindly allowed me to eat from their fresh kills. Their game lay frozen on the beach, so that when I was hungry, I would sit down by a walrus carcass and consume a good portion of raw meat. This food warmed me instantly.

After six weeks of hunkering down against the strong winds, I hadn't been able to take a single picture. Though I was accustomed to the sometimes long wait for the right conditions, I had grown disheartened. Finally, one Friday the weather improved dramatically; the clouds blew away to reveal the sun hanging high above the horizon. In the evening the ebb tide removed most of the ice from the beach, and I thought I saw

Male narwhals rest in Admiralty Inlet after feeding on Arctic cod, which live in the depths below.

A mother walrus and her newborn pup rest on a piece of multiyear ice in Foxe Basin. This type of ice is essential for walruses as it allows them to remain strategically located over their clam beds, which are only some 60 meters (200 feet) away, on the sea floor. Without these ice platforms, they would have to swim vast distances and burn valuable energy stores to access their nutrition. Female walruses remain with their young for up to three years, far longer than any other pinniped species. The floating ice allows the mother to easily whisk her pup into the water, away from danger if threatened by a polar bear.

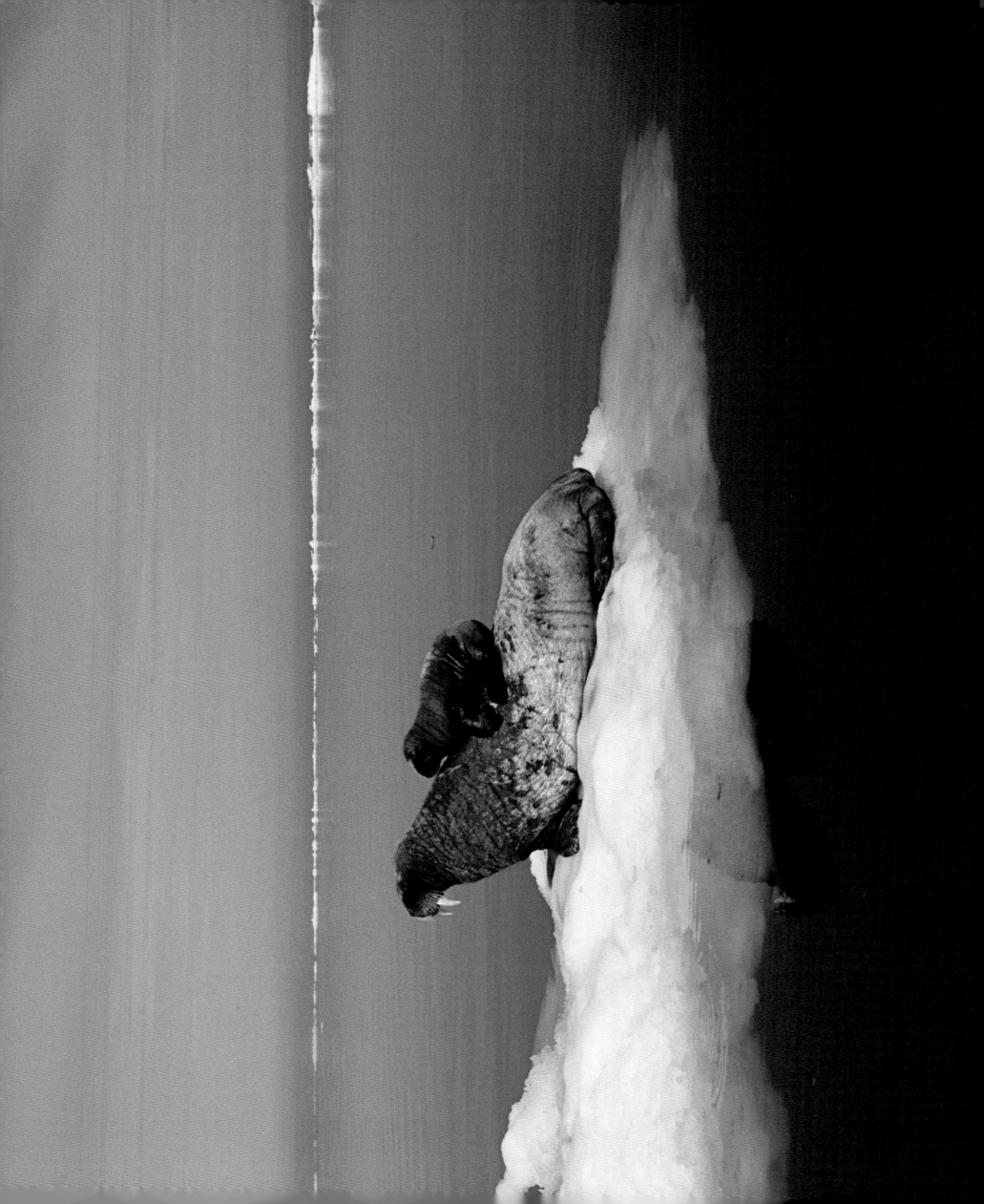

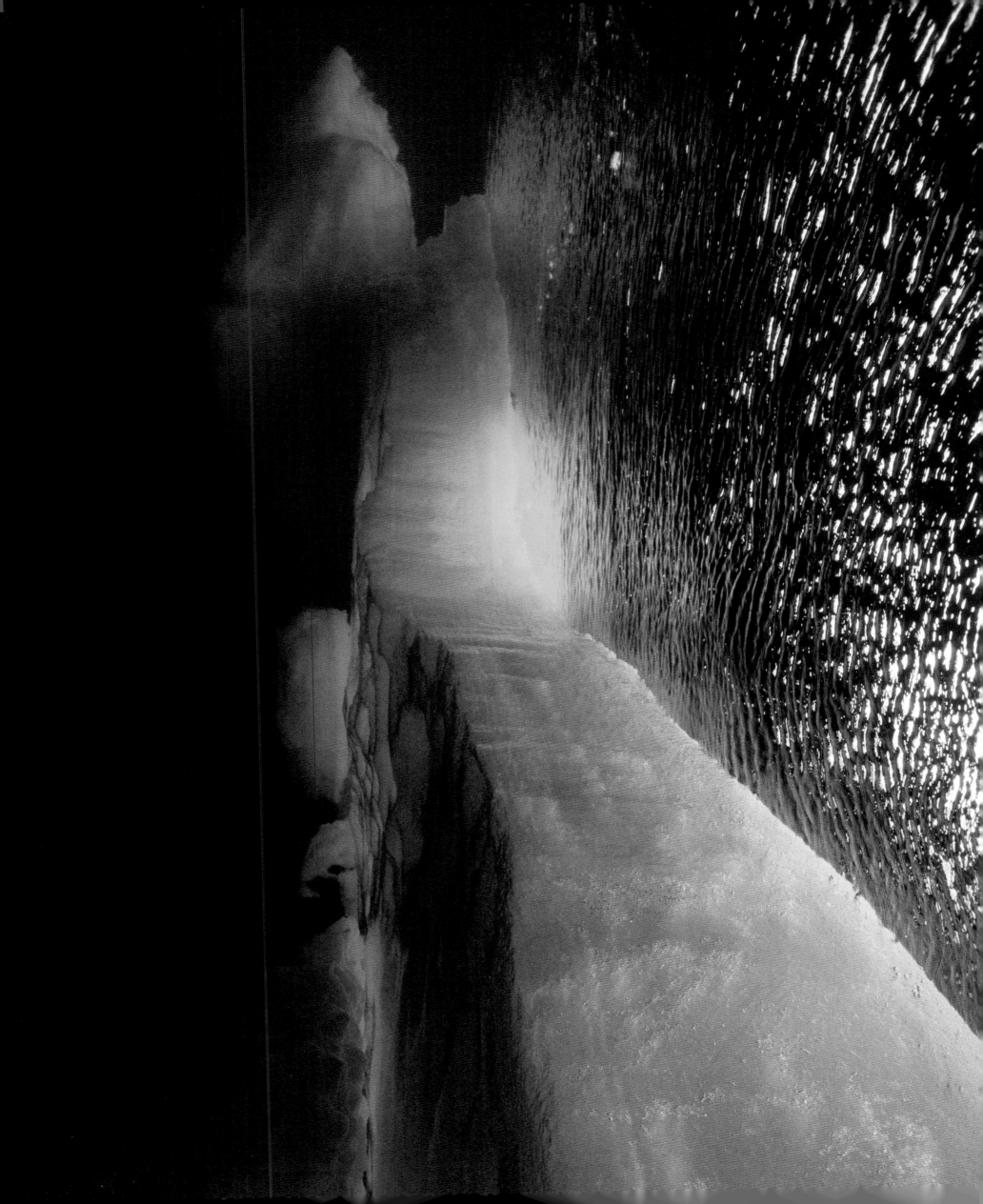

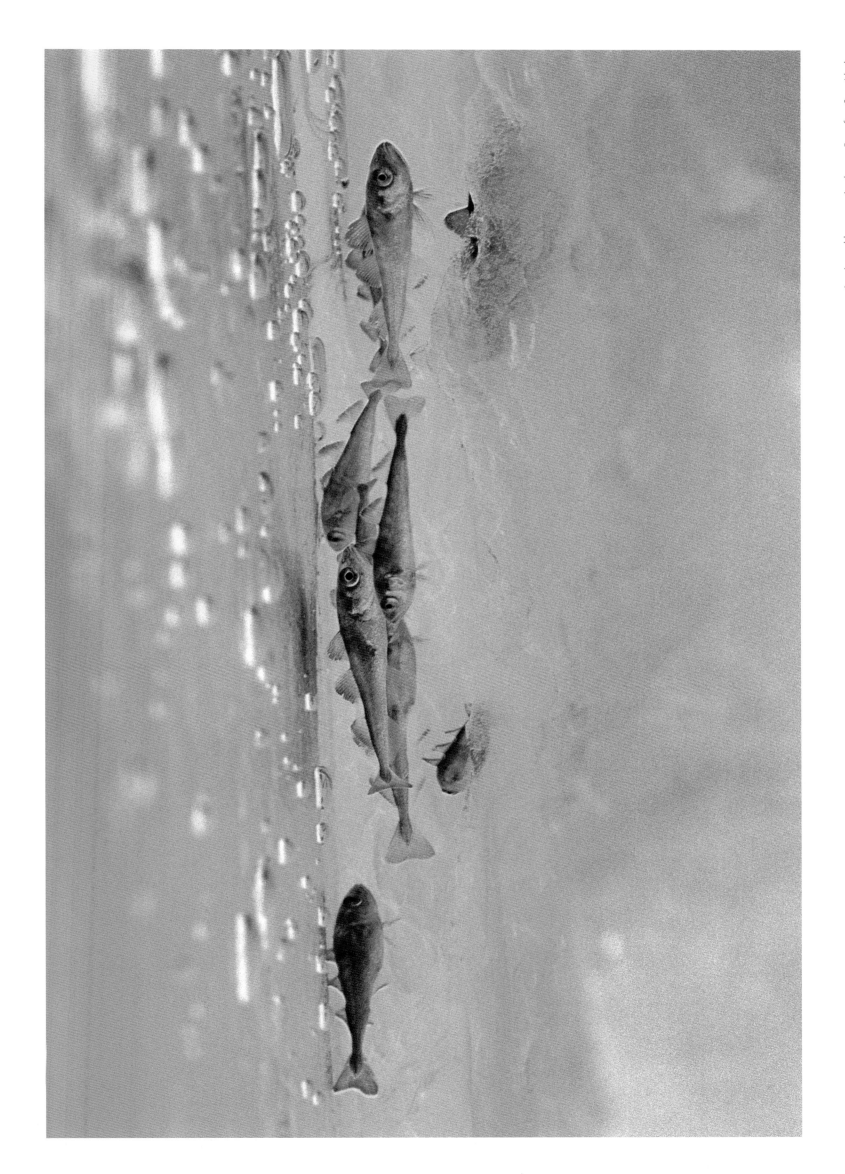

Arctic cod between ice layers, Beaufort Sea, Alaska.
< Freshly fractured ice edge, Beaufort Sea.

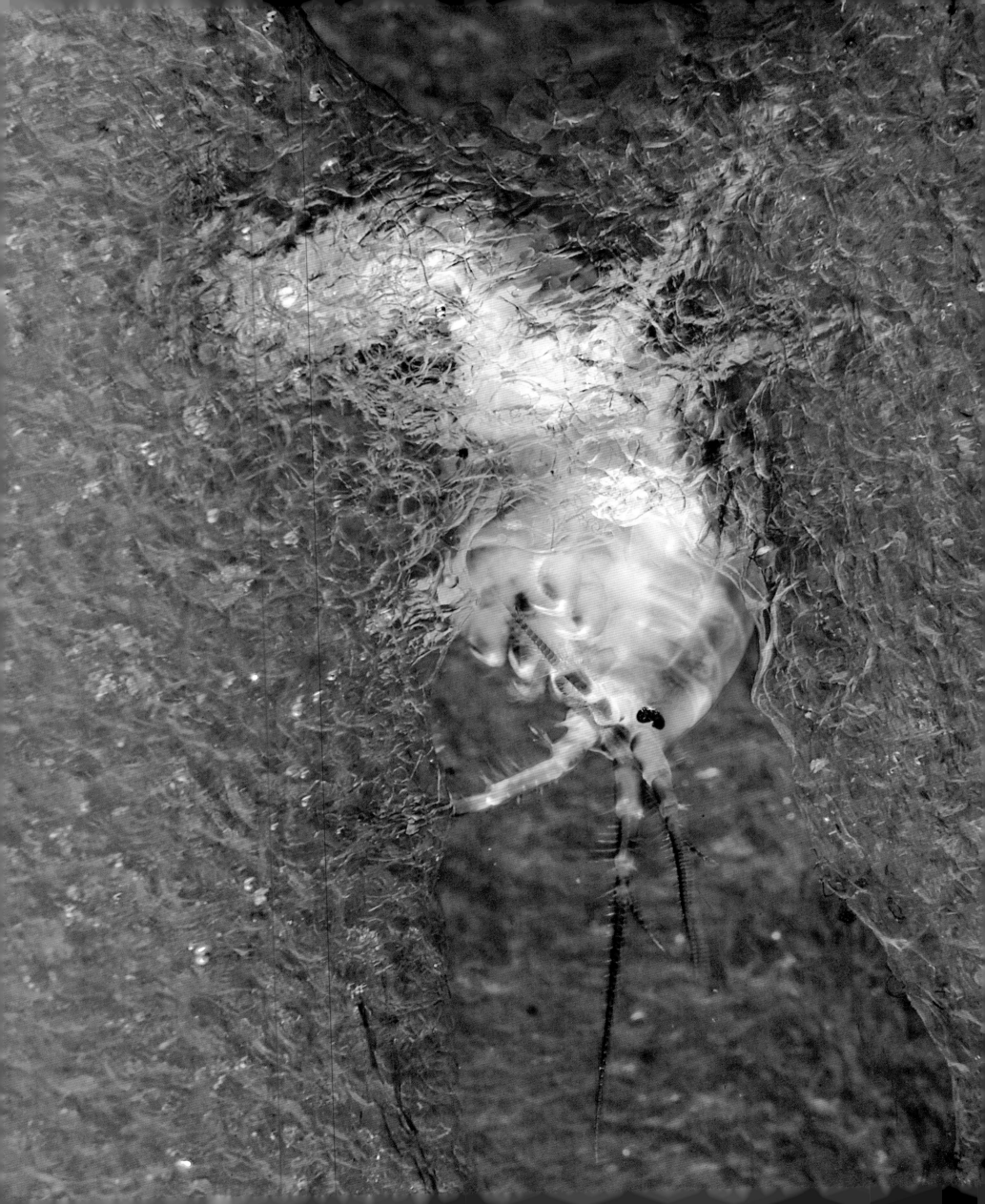

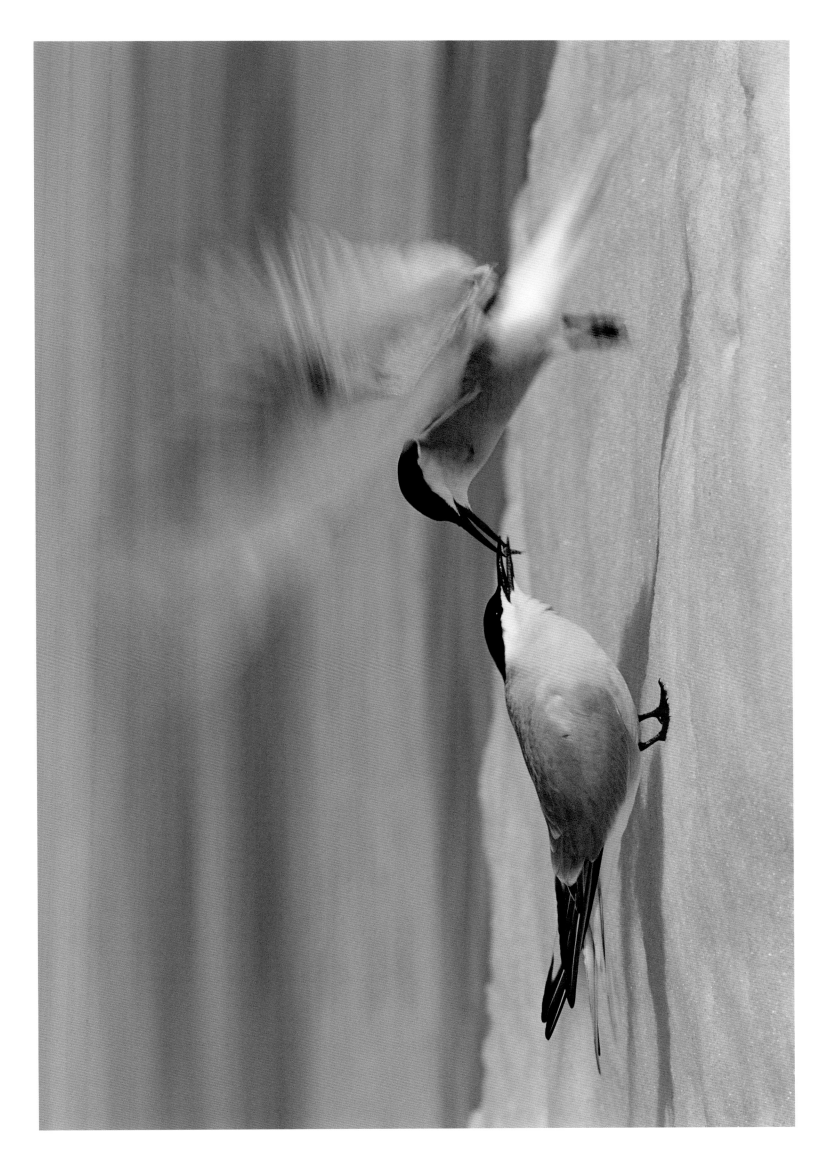

A courting male arctic tern delivers an amphipod to a potential mate, Foxe Basin.
< An amphipod nestling in its icy cocoon, Lancaster Sound.

69

In the Arctic spring, meltwater channels drain toward and down a seal hole, returning to the sea. White ice or snow reflects over 90 percent of the sun's energy back into space. As the snow melts from the surface, it reveals the much darker color of blue sea ice, which can then absorb up to 90 percent of the sun's energy, accelerating the melting process.

Northern fulmars soar over Admiralty Inlet.

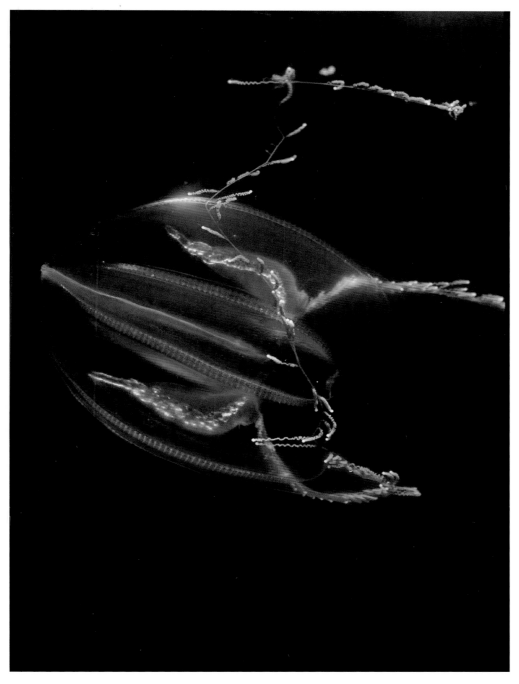

A ctenophore comb jelly, Canada Basin, Alaska.
< A fog bow at 1 A.M., Foxe Basin.

An ice-free Lancaster Sound presents a distinct contrast to the ice-choked Lancaster Sound that trapped and crushed the ships of explorers only a hundred years ago. Devon Island looms in the distance of the view that the many ships transporting goods between the Eastern and Western worlds will see as they ply these once frozen seas. Lancaster Sound is one of the richest wildlife habitats in the world, with a high biodensity of marine life. Soon large ships will be sharing these waters now teeming with life, potentially displacing migrating whales and seals.

A ringed seal scans for polar bears, Admiralty Inlet.

> Ice-free Admiralty Inlet in August.

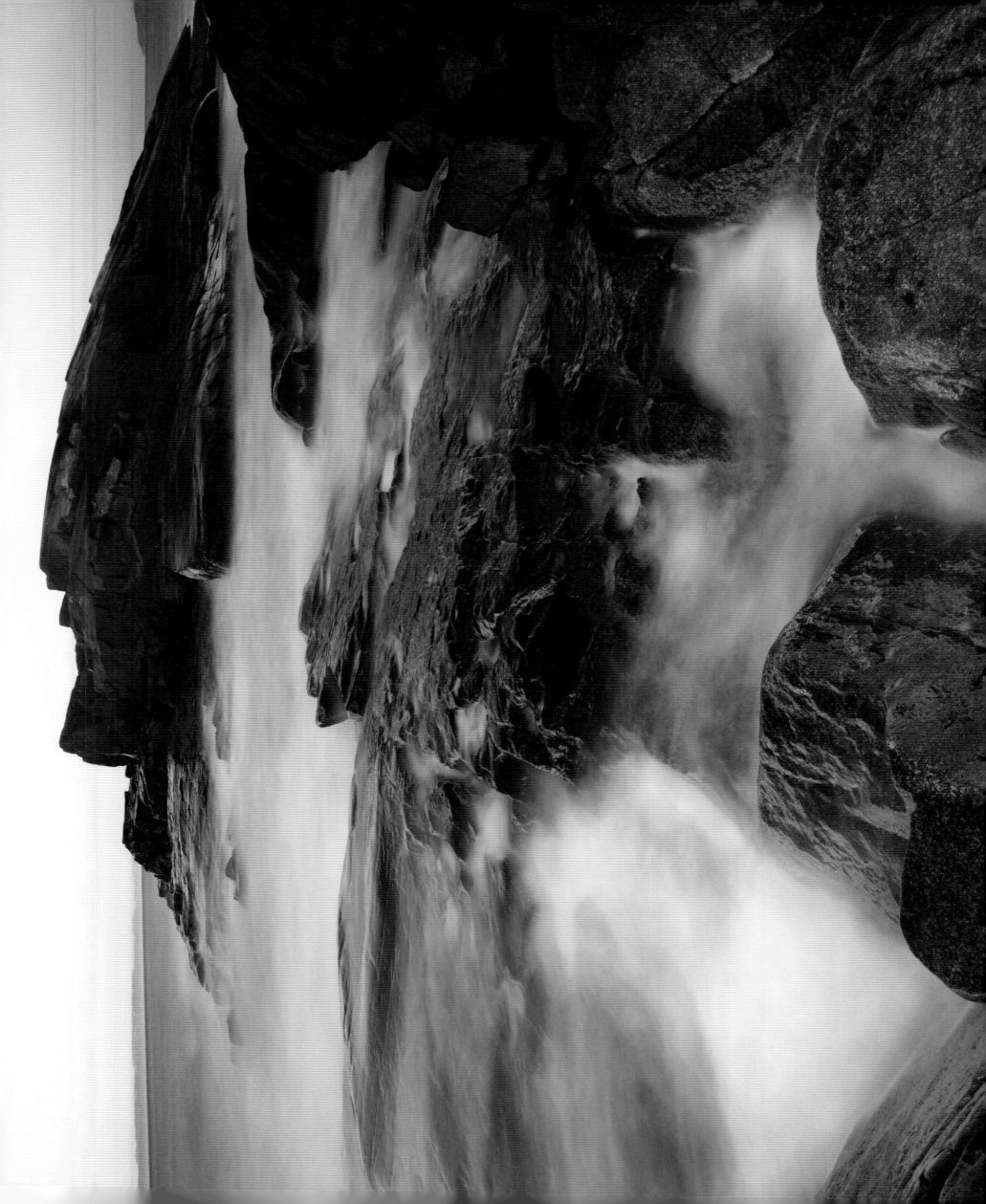

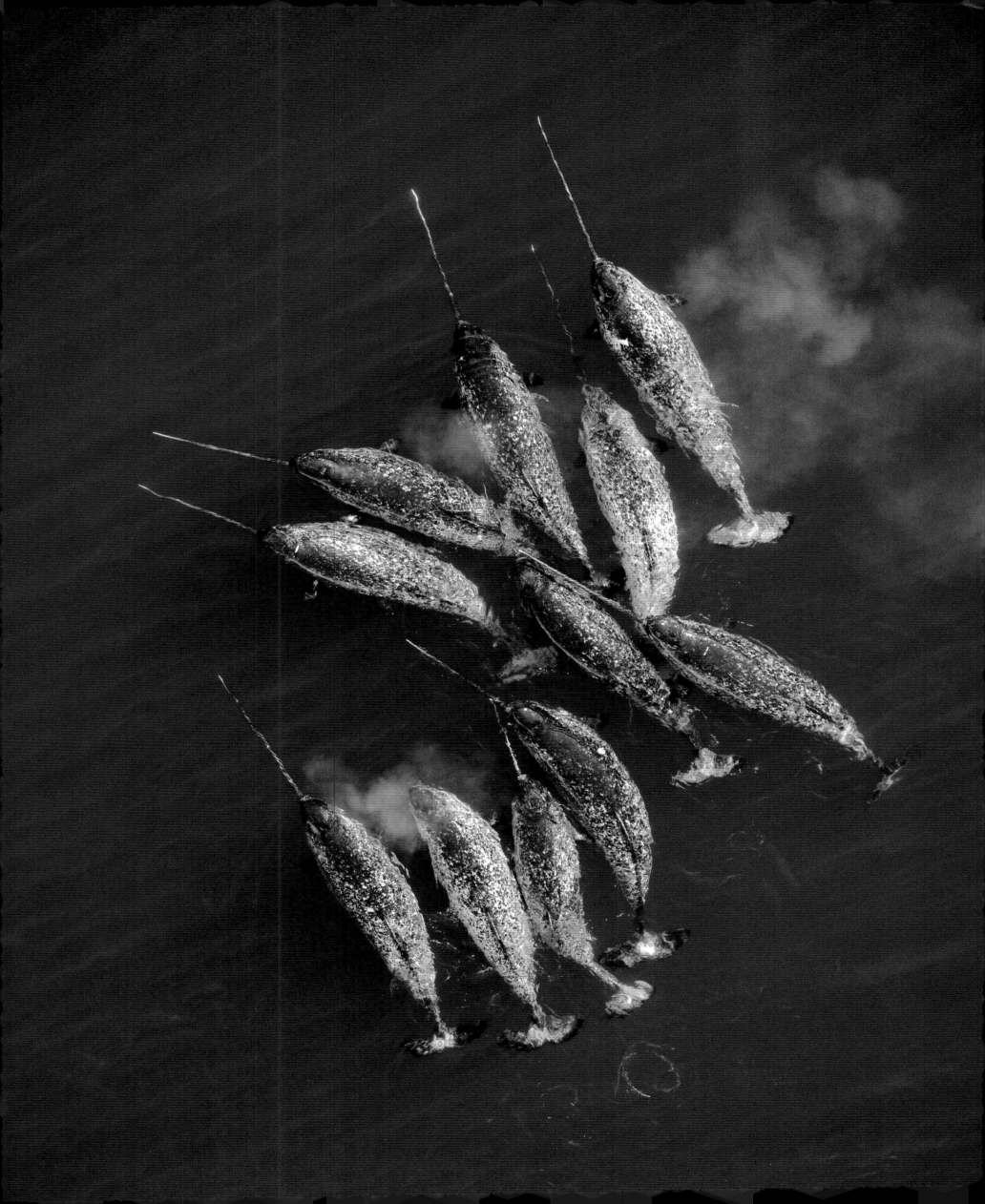

Last of the Unicorns

Of all the animals I have ever photographed, the Arctic's narwhals are the most mysterious, unusual, and elusive. Because of their incredibly shy nature and advanced echolocation, underwater images of these magnificent creatures are rare. They are particularly shy of humans, in large part because they have always been hunted, and with life spans of up to 120 years, they store up a lot of survival wisdom. These clever, sensitive animals, which live in a polar sea with up to 97 percent ice cover, can hide nearly their whole lives. You have to be extremely fortunate to catch a glimpse of them when they surface for air. Now, with the help of the Inuit hunters and an experienced Inuit guide, I was going to risk the fragile conditions of the early spring ice to try.

At this time of year, if the seas and winds are calm, it is possible to camp right at the floe edge, where the open water meets the fast ice. However, during high winds, camps have to be moved up to ten miles back from the ice edge onto thicker and safer ice. We had repeatedly reacted to splintering sea ice underfoot and had moved our tents regularly to more solid areas, always on guard against the possibility of a rampant, severing crack separating us from the land-fast ice.

When the strong winds pick up from the north, the large swells of the Arctic Ocean travel for miles beneath the frozen surface, undulating and straining against the solid lid of ice. In spring, the force of a surging swell can send fractures in every direction, and when the wind shifts to the south and the tide starts to ebb, the mechanics of wind and current quickly carry any unfastened ice out to sea. The trick is to always make sure that you are on the solid ice side of any crack, and that means frequent moves.

I had worked with my assistant, Jed Weingarten, and our guide, Gideon Qaunaq, for a full month, traveling, moving equipment, setting up camp, and talking with the elder hunters to assess the weather and ice conditions. In the end, even after the most thoughtful preparation, I knew from experience that, at best, I would have one good hour for photography; at worst, I'd get nothing. I had been trying to photograph narwhals for ten years, and that was exactly what I had to show for my efforts . . . nothing.

Nevertheless, like the local Inuit, I was eagerly awaiting the return of the tusked whales. For the first three weeks in June, we had camped on the frozen surface of Admiralty Inlet, waiting for a chance to photograph them. Though the air temperature was below freezing, we lived without any kind of heating

< Male narwhals pack together tightly, carefully wielding their eight-foot-long ivory tusks, Admiralty Inlet, Nunavut, Canada.

because, frankly, it is too difficult to leave a heated tent and go out to work in bone-chilling conditions. With no heat, I could acclimate to being cold. It is also better for camera gear to remain at a constant temperature.

Inside our small four-season tents, we had self-inflating air mattresses to insulate us against the hard, cold ice and −40°C (−40°F) rated, 800-fill, down sleeping bags—crucial in a climate where it sometimes becomes necessary to hunker down for five or six days at a time, waiting out a blizzard. We also had a cook tent, in which we prepared pots of soup made with seal meat to which we added dried, seasoned noodles for flavor.

Early one day Gideon left camp to go into town for more supplies. Before long, the wind started to blow, the sign of an impending blizzard. As the storm came in and grew stronger, Jed and I realized that it was likely that the fragile layer beneath our feet would soon break from the land-fast ice and float free. We would have to work quickly to break camp and move to safe ice. The wind whipped around us, beating our faces with stinging ice and snow as we hurried to pack up in a race we were losing to nature's elements. Sheer panic fueled our efforts. I didn't have to say a word; both of us knew that we only had a matter of minutes to dismantle our tents, load the gear onto the snowmobiles and sleds, and retreat at least 2 kilometers (1.2 miles) to solid sea ice. If the spring ice broke away before we could reach safety, we would be set adrift on a pan of ice, something that has happened all too often to hunters and film crews camped in this area of Admiralty Inlet.

As soon as we had packed our gear, we towed our sleds as fast as we could through the blizzard and barely managed a safe retreat. As we secured our equipment to the solid ice, the section where we had been just moments before cracked free and was carried away by the hurricane-force southerly winds and ebbing tidal currents. This scenario had played out countless times over the preceding weeks while we'd been awaiting the arrival of the narwhals at their traditional spring feeding habitat. We had not yet spotted the animals, and even as we had pushed our luck by staying on the weakening spring sea ice, my resolve had not waned. I was ready to start working, and yet all we could do was endure one storm after another.

The return of the narwhal, the small, tusked whale of northern polar seas, is my favorite time of year in the Canadian Arctic. After months of darkness, extreme winds, and temperatures as low as −40°C (−40°F), winter gives way to spring, and the sea ice covering Lancaster Sound begins to splinter. Open stretches of water, called leads, become travel lanes for the small whales as they follow the retreating sea ice toward their ancestral summering grounds around Baffin Island. I wanted to do something extraordinary, monumental, and nearly impossible, given the extreme shyness of these whales: I wanted to photograph them, relaxed, performing their natural activities at very close range. I wanted to be the proverbial fly on the wall in their environment.

For this reason, although I was tired of moving camp, I still looked forward to the splintering of the sea ice because it meant the arrival of the narwhals. As soon as a new crack opens up in the sea ice, narwhals, bowhead whales, and occasionally beluga whales push into the narrow leads to access food. In the wintering grounds of Baffin Bay, between Baffin Island and Greenland, the narwhals feed on turbot, which are like medium-sized halibut—9-kilogram (20-pound) flatfish that live on the ocean floor, around 1,500 meters (5,000 feet) deep. Narwhals can dive in excess of 1,800 meters (6,000 feet) to eat this large fish and then return toward the surface, using echolocation to find a narrow lead in the ice, a place to surface and breathe. In the spring, they migrate through ice-choked Lancaster Sound to various areas off Baffin Island and Prince Regent Inlet, where they push deep into the leads and inlets. There they remain throughout the spring, summer, and fall. The strong site fidelity of the narwhals draws them back to the same places every year, at nearly the same time.

In my ten years of visits to the Arctic Bay floe edge in search of narwhals, I had watched and learned from the Inuit. As my guides, they taught me the skill of working on the floe edge and how to endure the elements with patience. Over the years I came to cherish the hours of solitude and meditative silence that sometimes extended to days and weeks as I waited. But I had a job to do; I needed pictures of narwhals. I had asked the more experienced Inuit elders if it was possible to get close to narwhals. They smiled and said "eeeeee" ("yes" in Inuktitut) and pointed out toward the areas where the ice is constantly moving and drifting out to sea—a place far too dangerous for anyone except the most experienced of hunters, and even they are able to remain there only briefly. The Inuit described places where the pack ice is rotting, opening up holes that allow the narwhals to surface and catch their breath. These holes develop under large pans of ice that can span several miles. Rather than swim out to open water, the narwhals

stay under the ice, closer to the swarming masses of Arctic cod on which they feed, and when they need to breathe, they use echolocation and their eyesight to find openings to the surface. As they told me about the narwhals, to show me how close they could get to them, the Inuit elders reached out and grabbed at the air as if they were taking hold of a narwhal's tusk.

Even armed with this knowledge, I knew that I could stand on the floe edge for the rest of my life and never encounter the narwhals as intimately as the Inuit had described. I needed to change my strategy. I could not get the vision out of my head of standing beside a pod of narwhals lying at the surface with their tusks pointed skyward as they took turns surfacing in the small life-giving holes opening in the spring ice. I left the sea ice and went home to make a plan.

Essentially, this became the story of the hardest photo shoot I'd ever undertaken, one that only succeeded through the generosity of a number of people. To get out into the drifting pack ice where the whales were supposed to be feeding, I knew I would have to try a new approach. I'd have to get there by plane. I bought an ultralight airplane with floats that would allow the plane to take off from sea ice or water. I assembled it, and then I learned to fly it. That turned out to be the easy part. Transporting the plane to the high Arctic proved a greater challenge. In transit, the battery fell out onto the floor of the plane and shorted out on the rudder cable, causing a small fire in the cockpit and melting all of the engine wiring. With the help of experienced pilot Brian Knutsen—who rewired the engine and fixed the rudder cable in under 24 hours—and another friend, who transported the plane 2,250 kilometers (1,400 miles) to northern Baffin Island, Brian and I were soon camping on the sea ice 80 kilometers (50 miles) off the coast of Baffin Island.

That night we were tired, but the midnight light was incredible, so Brian and I took flight with the doors off, ready to shoot. About half an hour into the flight, at an altitude of 300 meters (1,000 feet) some 30 kilometers (19 miles) out over the drifting pack ice, the engine started to die. In the backseat, Brian was handling the controls, trying to maintain altitude with the poorly functioning engine. He knew that a forced landing would be disastrous, as the ice below was jagged and shattered, and we were many miles from any help. Seated up front, where the views were spectacular and the light was absolutely beautiful, I was grateful the plane was in the hands of an experienced pilot. Trusting that everything would be okay, I

kept shooting. When Brian finally came on the radio and asked me to help him keep the plane going by manually priming the engine, I realized things were much more serious than I'd imagined. In fact, the damp, cold air had allowed ice to form over the carburetor, essentially starving the engine of air and fuel. We made it back to camp just as the crankshaft was failing. The engine was finished.

Undeterred, I ordered a new engine and had it shipped by overnight service to Arctic Bay. Three weeks later the engine arrived. We had to pick it up by snowmobile and sled and pull it across 115 kilometers (71 miles) of ice from town to our base camp. Installation was delayed by a series of blizzards. Despite the fracturing ice and gusting snow, we held our camp position, monitoring our pan of ice and keeping an eye on the dangerous wind from the south. At one point, desperate for sleep, I took a nap. When I awoke, I turned on my GPS to make sure that our pan of ice was still holding fast and saw that not only had it broken loose but we had already drifted 3 kilometers (about 2 miles) out to sea and were moving at a rate of about one kilometer (.6 of a mile) per hour. I sent Jed and a local guide named Dexter Koonoo out to the pan's edge on snowmobiles to look for a way to reach land or to see if they could jump the ice from floe to floe and get back to solid, land-fast ice. For 24 hours I drifted alone with the broken airplane, sure that I would need to be rescued by helicopter and that the project was over. Then I heard the approach of a snowmobile. My Inuit friend and guide Dexter had returned; a young man in terms of years, he is sage when it comes to navigating and surviving in the Arctic. He hooked up the plane to his snowmobile and managed to tow it 15 kilometers (9 miles)—connecting the dots, floe after floe—until we reached a safe piece of ice.

The blizzards continued and Brian and Dexter did a masterful job of installing the new engine under the protection of a large tent. It was now mid-July and the sea ice was very unstable, thin, and constantly breaking off. Most of the Inuit hunters were leaving the area because there wasn't any point in risking the loss of their snowmobiles while hunting narwhals. But the narwhals were around, and I had been lucky enough to finally get underwater photographs of them. I felt compelled to stay. All we needed were some aerial photographs, and I still hoped for the incredible encounter that I had been envisioning for over a year. Finally, the weather broke and Brian and I found ourselves airborne once again, soaring above the brilliant sea ice.

We hadn't been out for more than twenty minutes when I saw movement below. I looked closer and what I saw caused me to stare in disbelief: hundreds of narwhals swimming in leads and in the open water. I took many pictures but was still not satisfied; I held fast to my plan to find whales surfacing through small holes in the rotting ice. We returned to camp, refueled, and continued the search. About 40 kilometers (almost 25 miles) from the main ice edge, we saw them: huge pods of narwhals—maybe as many as a thousand—filling every hole and lead in one huge pan of ice. I knew that we had to land, but the conditions were dangerous: rotting and rough ice, plus a polar bear and her cub that were standing close to the hole where I wanted to photograph the narwhals. Nevertheless, Brian managed to land on a tiny ice bridge. The polar bear eyed us warily. Not knowing for sure, I promised Brian that the bears would leave us alone. We hadn't had capacity to bring a weapon of any sort; the plane was at maximum weight as it was. It was a gamble that I was willing to take. We left the plane at a distance and walked to where we could hear an incredible number of blows and see the narwhal tusks en masse, reaching up toward the sky. When we arrived the blows, squeals, groans, and splashing of the animals were near deafening.

I had a knot in my stomach and could hardly breathe; I was completely overwhelmed by what I saw. As many as ten whales were taking turns rising through holes that were only a few feet in diameter. They had to rise vertically as the hole was too narrow for them to lie flat when they came to the surface and fought to catch a breath. They took turns and only managed one breath before going back under to wait their turn for a second breath. There wasn't any panic and their movements seemed calculated and gentle with one another, much like their coordinated hunting efforts when rounding up swarms of Arctic cod. They arrived at the surface in rotating groups, and then disappeared together for up to half an hour. I could recognize individual whales by their scars. On occasion a narwhal would surface with a cod speared on its tusk.

I shook myself free from my fascination and surveyed the wide vista of ice around me, stretching flat, pans of ice 3 kilometers (2 miles) across and dotted with holes far into the distance. Beyond that, 2,000-foot cliffs rose vertically out of the sea. In the larger holes, tens and even hundreds of whales were rising to the surface and lying flat to rest for a few minutes while carefully wielding their tusks so as not to spike one another. As more narwhals surfaced, the group packed tighter and they laid their tusks on each other's backs. They took several long, slow breaths before slipping back into the depths.

I struggled to stay calm, controlling my breathing and holding the camera steady. I could get so close to them and they were so densely packed right in front of me that it seemed I could have run across their backs. They were stacked on top of each other like cord wood, and just as I had envisioned. As the Inuit elders had described, I could have reached out and grabbed a number of their tusks. This was the culminating moment of my years of trying to close in on these elusive animals.

Back at camp, Brian and I awoke the following day eager to take flight again, but the ice was becoming too dangerous. Instead, we broke camp and started back to town. With the ice disintegrating around us, I should have been extra vigilant, but in a moment of carelessness, I fell through the rotten ice. As I was going under, I reached up and grabbed a rope to stop my descent. I felt my shoulder fully dislocate and I knew immediately that the project was over. Several hunters helped me out of the water and onto safe ice where, after an hour of effort, Jed managed to pop my shoulder back in. During this excruciating process, every time he pulled on my arm to try and relocate it, I winced in pain, but what I visualized behind my squinting eyes were hundreds of narwhal tusks pointing skyward. I had to smile because I finally had the story and the rare images of the most extraordinary creature I will likely ever have the privilege of photographing. My reverence for these astonishing creatures had only increased my desire to help preserve the sea ice—their home and natural habitat.

> Narwhals cross tusks as they jockey for a breath, Lancaster Sound, Nunavut.

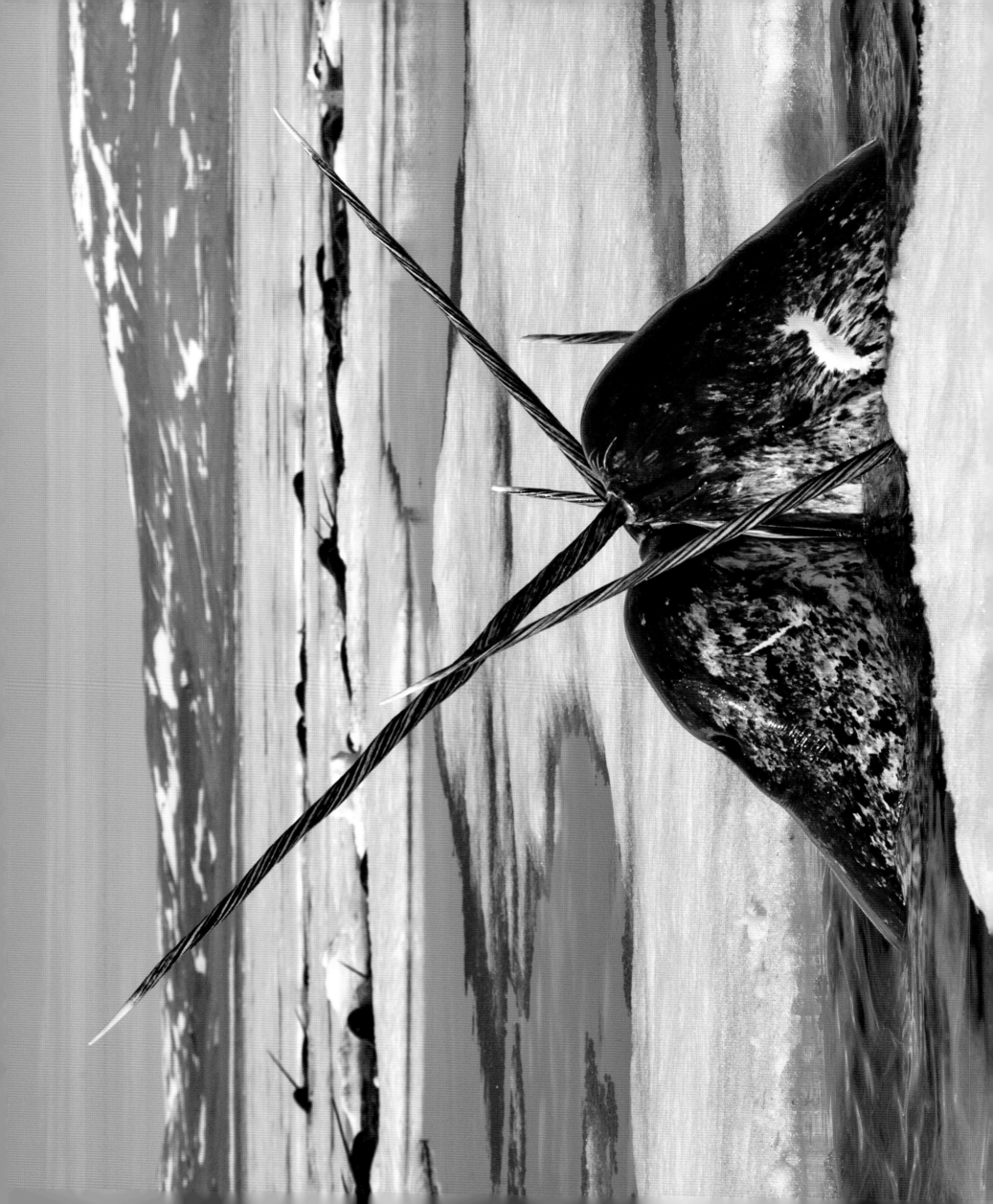

A lone female narwhal, Admiralty Inlet.

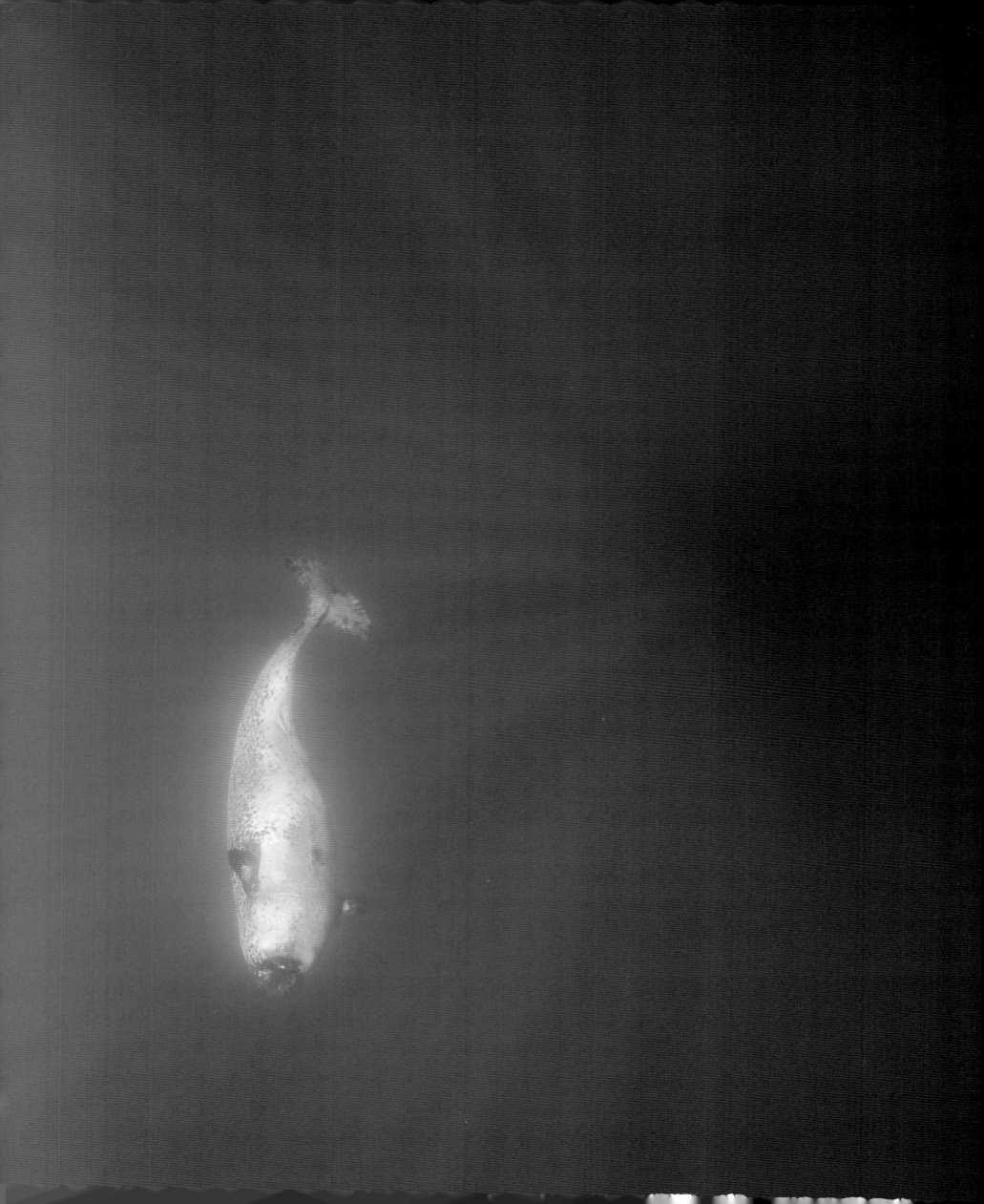

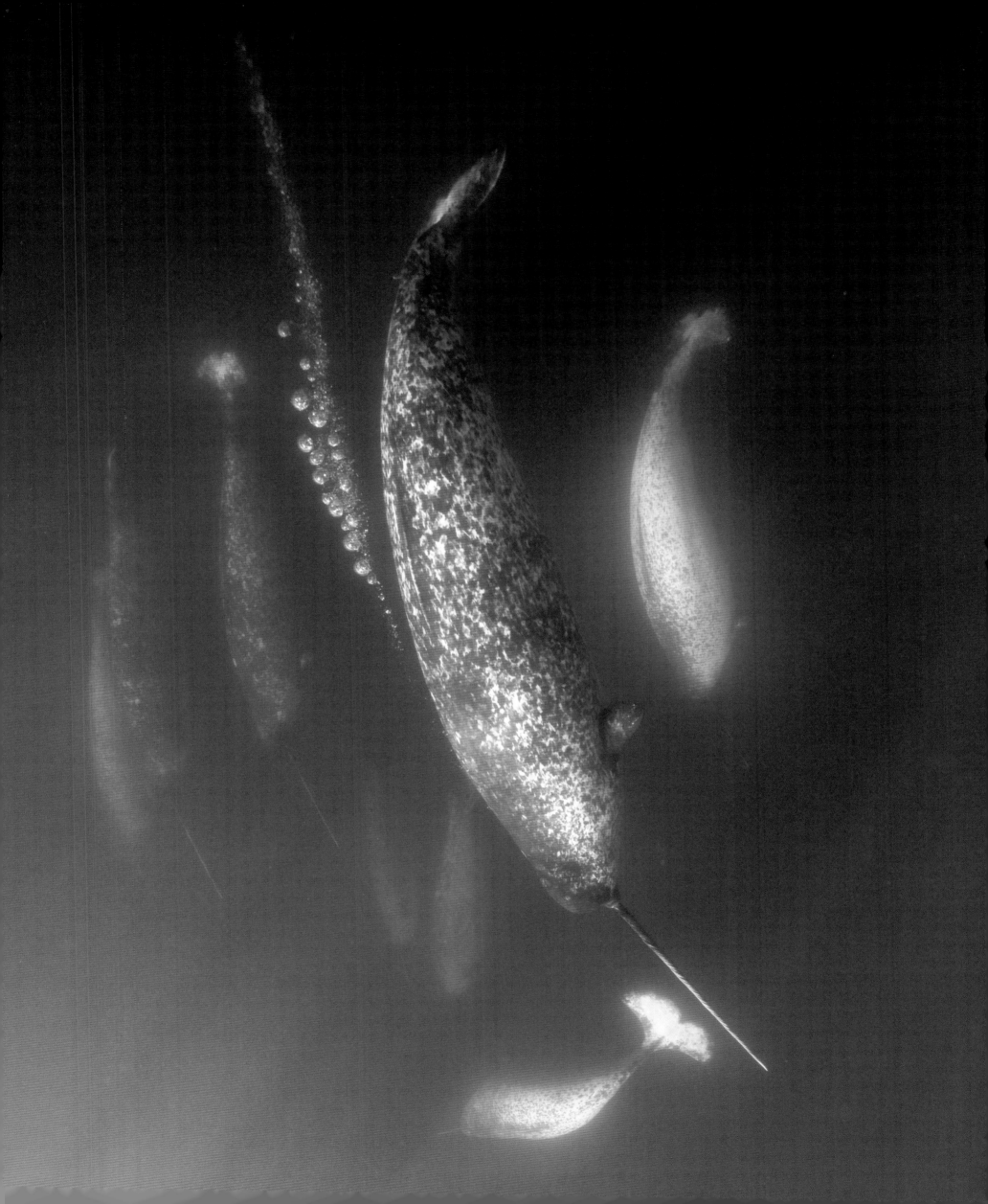

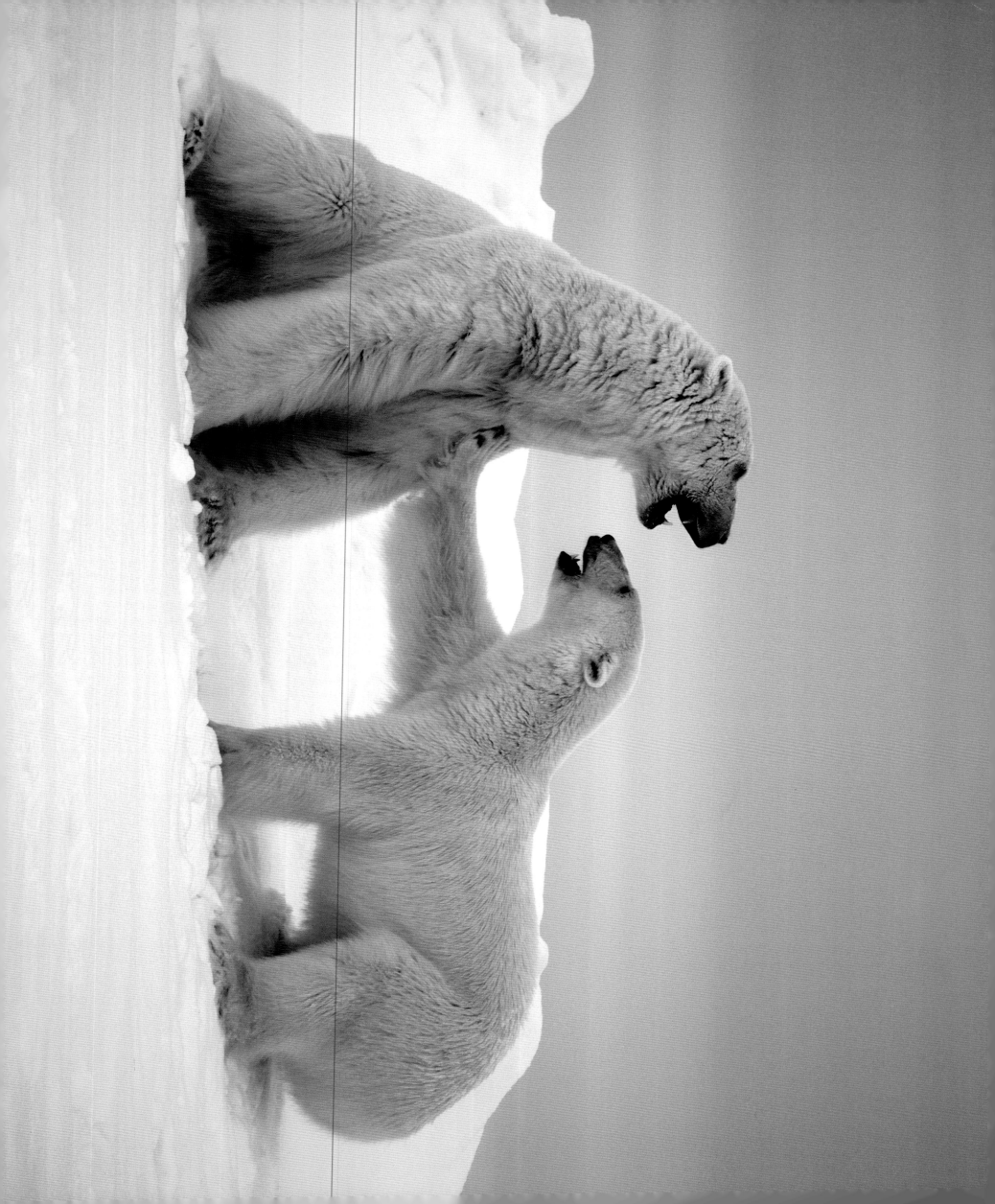

Svalbard: Polar Paradise

Svalbard is a place of extremes. This frigid, treeless archipelago stretches across icy seas roughly halfway between mainland Norway and the North Pole. Beautiful and austere, the nine islands—slightly smaller than Mongolia in terms of square kilometers—are mere specks in the vast Arctic Ocean. From the air, Svalbard appears such a lifeless, windswept world that one wonders if anything can possibly live in such a place. Cliffs rise 600 meters (2,000 feet) directly out of the frozen ocean surrounding the islands. Homes and buildings in the colorful town of Longyearbyen on the island of Spitsbergen seem to be hunkered down against the harsh elements. The roughly 2,000 residents are hearty people, accustomed to subfreezing temperatures and long months of polar night.

While the human carbon footprint is small and would not contribute directly to deterioration in the habitat, recent changes in the melting rate of the sea ice are having a dramatic effect on this pristine habitat and its wildlife. Svalbard truly is the land of the polar bear. There is no better symbol of the far north than the polar bear and, tragically, the species is profoundly affected by Arctic warming. I had spent much of my career studying and photographing polar bears in Canada, first as a wildlife biologist and then as a photographer, but this would be my first time photographing them in Norway. There are no significant differences between the two populations; they are equally threatened by the disappearance of sea ice. Without it, polar bears have no hunting platforms from which to catch seals, and when they do hunt during the summer months, the pans of ice on which they float are smaller and farther apart than in the past, causing the animals to use valuable energy as they swim and leap between the ice floes. With each new season of melting, polar bears lose more of their habitat. I wanted to photograph the polar bears of Svalbard before the challenges became too great.

Like many remote places, Svalbard grows on you. It takes some time to gain an appreciation for its stark beauty and the remarkably diverse abundance of life within this realm. The steep cliffs are well suited for the nesting birds that arrive by the millions in the spring: guillemots (murres), dovekies (little auks), kittiwakes, and fulmars line the nesting cliffs, filling every square meter of the towering monoliths. From a distance, the cliffs appear to be white limestone, but closer inspection reveals that they are covered in guano—the white excrement of the winged creatures.

< A female polar bear rejecting the advances of a massive, battle-scarred male, East Svalbard, Norway.

A visitor approaching the cliffs by boat can be overwhelmed by the extremely loud raucousness of the congregation of over a half-million seabirds. That these birds all come together is testament to the bounty to be found in the seas below. The varied species come to nest and raise their young on the plentiful nourishment in the surrounding waters: amphipods, copepods, and fish. When guillemot chicks are nearly developed enough to take wing, adults gently guide them from the safety of the nesting area to the cliff's edge. Because their wings are too immature to bear their weight, the chicks leap from the edge and fall in a somewhat controlled but mostly chaotic flight toward the ocean, up to 600 meters (2,000 feet) below, with an adult following close behind. When they reach the sea, the lightweight chicks skip like pitched stones across the surface of the water before they come to a halt. Until they are capable of true flight, these immature birds are easy pickings for predators such as seagulls and walruses. On the shore, arctic foxes patrol the beaches looking for chicks that do not reach the water. The parents continue to feed their surviving young as they float on the sea, nurturing the chicks until they are strong enough to take flight.

Only twenty years ago, sea ice completely surrounded Svalbard, providing an essential habitat for seals, polar bears, and other Arctic creatures. But now, sea ice is quite scarce in the inlets and fjords of Svalbard. Many species of birds, seals, and polar bears also wait for the calving ice (the ice that regularly slides down the face of the glaciers and crashes into the sea) to provide them with temporary platforms on which to rest or from which to hunt. But even that option is limited. Many of the glaciers of Svalbard have receded to the point that they calve on the land and not into the sea. Over 50 percent of Svalbard remains entombed in glaciers, but this picture is rapidly changing as ice caps and glaciers retreat and some disappear all together.

Between my two visits to the archipelago, the changes were dramatic. In 2004, my guide, Shaun Powell, and I spent weeks familiarizing ourselves with the lay of the land. We explored sea and glaciers, cruising the fjords in a Zodiac and mapping out the areas and subjects I wanted to photograph for a story I was scheduled to shoot the following year. When we found a particularly beautiful fjord in northwest Svalbard, I made careful records of the terrain and noted the coordinates.

Because the sea ice in the fjords was thin and unstable, I was not able to return the following year as planned. In 2006 the conditions were no better;

ultimately, I had to delay my work for yet another year rather than risk poor sea ice conditions in the fjords, where it wasn't safe to travel by snowmobile. When Shaun and I finally returned in 2008, we took the Zodiac out and followed my detailed directions to the beautiful spot I'd picked in 2004. But nothing looked familiar; none of the landmarks were right. Had I been careless with my notes? We doubled back, passing in front of one small glacier several times, checking and rechecking my directions and coordinates. Instead of the magnificent glacier face dropping straight down into the ocean, we were looking at a bay of islands and rocky outcroppings. What appeared to be "our" glacier was still there, but much of it was already on land and no longer calved into the sea.

After checking our GPS coordinates yet again, and cross-referencing our location with nautical charts, we confirmed that we were in the right spot, but climate change had beaten us to it. A massive glacier melt had reduced the leading edge of the once majestic and towering glacier into a watery bay. My heart sank as I realized that my plan to photograph in this once dramatic setting had been thwarted. But I quickly realized that the greater disaster was the effect of the melt on wild creatures that depend on the seasonal melting and freezing cycles of sea ice and glacial ice for their survival. With the increase in warming, the calving rate of glaciers has exceeded the regeneration rate. Some of the giant glaciers that lined the fjords of Svalbard have disappeared entirely. Rocky cliffs reveal only the moraines, scars of where the mighty glaciers once flowed from mountain to sea.

While all of Svalbard lies hundreds of miles above the Arctic Circle, the warm waters of the Gulf Stream nourish the archipelago's abundant marine life. Like the krill in the waters of Antarctica, copepods and amphipods provide sustenance for many species in the Arctic. These small crustaceans feed the largest mammals on the planet, including the blue whale. Species such as the beluga whale, walrus, and ringed seal feed on the middle levels of the rich food chain of this ecosystem. And when all of these animals are well fed, the animal astride the top of this food chain—the polar bear—is satisfied as well. Historically, this has been the case: more than 3,000 polar bears live in the islands of Svalbard, traveling from solid ground to floes of frozen ice, eager to feed on seals, the denizens of icy lairs just below the surface of the sea ice. For thousands of years, polar bears have lived in this way, but with the sudden disappearance of their floating hunting platforms, the bears must develop new strategies to catch seals.

In the Canadian Arctic more than 600 polar bears are shot annually, but in Norway it is illegal to hunt the species, and strict guidelines ensure that bears are not harassed. Because humans are not a threat to them, the polar bears of Norway are much less wary than their Canadian cousins, so they are fairly easy to locate and photograph.

For the winter component of the assignment I hooked up with my friend Karl Erik Wilhelmsen, who had agreed to serve as my guide in Storfjorden, on the east coast of Spitsbergen, the largest island of the Svalbard archipelago. This was a particularly cold area that had substantial sea ice that year. One night, just after midnight, we were sitting talking in our tiny hut. Just outside the window we saw a huge male polar bear walking gracefully across a narrow strip of sea ice alongside the pressure ridges, apparently in search of seals. Pressure ridges form in the ice each fall when ice pans push up against one another, lift into the air, and then freeze solid for the winter. Seals find shelter under these ridges, where they maintain breathing holes and birthing lairs.

The approaching bear was missing an ear, proof of the intensity of the battles that take place between dominant males during breeding season. I was thrilled with the prospect of photographing this bear in its natural environment. We quickly packed up the photography gear and followed him across the ice, hoping to get a closer look. After a couple of hours of attempting to sneak up on him, but falling farther and farther behind, we realized that his pace was just too fast for us. Also, we saw that he was following a smaller set of polar bear tracks with a dogged determination that led us to suspect they must be those of a female; after all, it was breeding season.

We hurried back to our little hut and hopped on our snowmobiles, hoping he hadn't moved too far away for us to pick up the trail. We searched for over an hour along the floe edge and eventually, out of the mist, we caught a glimpse of the big male. We then saw the object of his intentions: he indeed was in pursuit of a female bear.

We couldn't believe our luck. It is extremely rare to observe polar bears mating—a ritual that I had always been determined to photograph but had never witnessed. The vastness of the bears' home range means that they can roam as far as necessary to find a mate, and they often carry out their mating rituals far away, out on the frozen sea. Hoping to remain undetected by the pair, we shut down our snowmobiles almost a kilometer from the bears. The female caught our scent, but rather than becoming nervous, she began to move toward us. She came quite close, within 30 meters (100 feet), and suddenly lost interest, lay down on a snowdrift, and went to sleep. We didn't want to start our snowmobiles and risk startling her, so we sat quietly, in peaceful coexistence with her. The male bear, which had been following at a slow but concentrated gait, watched her nestle in for her nap and then approached her, seemingly a bit woefully. He sniffed at her and nudged her but got no response. He kept intermittently nudging her, trying to entice her—most likely they had already been breeding for several days—and when she couldn't be roused, he finally lay down beside her and went to sleep. Occasionally he would wake up and try again to rouse her. Each time he made an advance, she got up and pushed him away with a swat to let him know that she wasn't ready. She then settled in and went back to sleep.

We kept our vigil in the −34°C (−29°F) conditions for more than 20 hours, all during the day and then throughout the sunlit evening, watching the pair and hoping that they would resume their mating activity. The female bear became more and more annoyed as the male continued to nudge her. Finally she stood up and ran toward me where I sat on my snowmobile. We had our snowmobiles ready to go, just in case something like this happened. I jumped off mine and hopped on with Karl Erik, who drove a short distance away. We turned and watched the female rip apart the seat of my snowmobile, crunch my new goggles, pull some gear off my sled, and play with my tripod.

Fortunately there wasn't any food onboard, so she quickly lost interest, walked back to her snowdrift, and went back to sleep. We sat for another five or six hours, trying to keep warm without making any distracting or sudden movements. Finally, she stood up, walked over to the sleeping male, and nudged him gently, letting him know that she was ready. He slowly got up as she presented herself to him, then moved toward her. Just as he was about to mount her, another male of roughly the same size came charging around the side of a large block of ice, taking us all—bears and humans alike—completely by surprise. The two males let out deep guttural moans that pierced the cold Arctic air and they postured toward each other. Suddenly, deciding he couldn't win this battle, the one-eared male took off running. The female wanted nothing to do with the intruder and she ran off as well. We also soon left, dejected about the missed opportunity, but still inspired by what we had just witnessed.

As we started toward camp on our snowmobiles, I turned and saw the female we'd just been watching following us. After trailing us back to our camp, she hung around while we unpacked some of our gear and carried it into the hut. Once inside, just as I put my things down I heard a deep breath being exhaled behind me. I slowly turned and saw the most extraordinary sight: the polar bear had poked her entire head through our little window. She seemed much larger than she had on the sea ice, probably because her head took up the whole frame of the window. I grabbed my camera and managed to snap a few photographs of her looking into our hut. But the little cabin was nearly pitch black now that she'd blocked the light from the window with her head. To get a decent photograph, I knew I'd need to add some light to her face, but my flash was still outside on my sled. I tried to sneak out to get it, but she anticipated my move and came to the door. When I turned back, she returned to the window. I saw a kerosene lantern that looked like it had been sitting there unused for years. I lit the wick, but the light from the lantern was not enough. I scanned the room for something that would cast some light on the bear's huge, inquisitive face. My eyes fell on my laptop computer, which was inches away, on my sleeping bag. I grabbed the computer and opened up a blank white page. With the laptop in one hand and the camera in the other, I was able to get a portrait with just enough light to fill in the shadows on her face.

I shot a number of images of this trusting animal, so wild, and yet so vulnerable. It was only after she had satisfied her curiosity and pulled her head back through the window opening that I reflected on what had just happened. The intimate encounter was exhilarating, but it was also disheartening to imagine that this magnificent animal could become extinct.

> Male bears spar under the low light of winter, Svalbard.

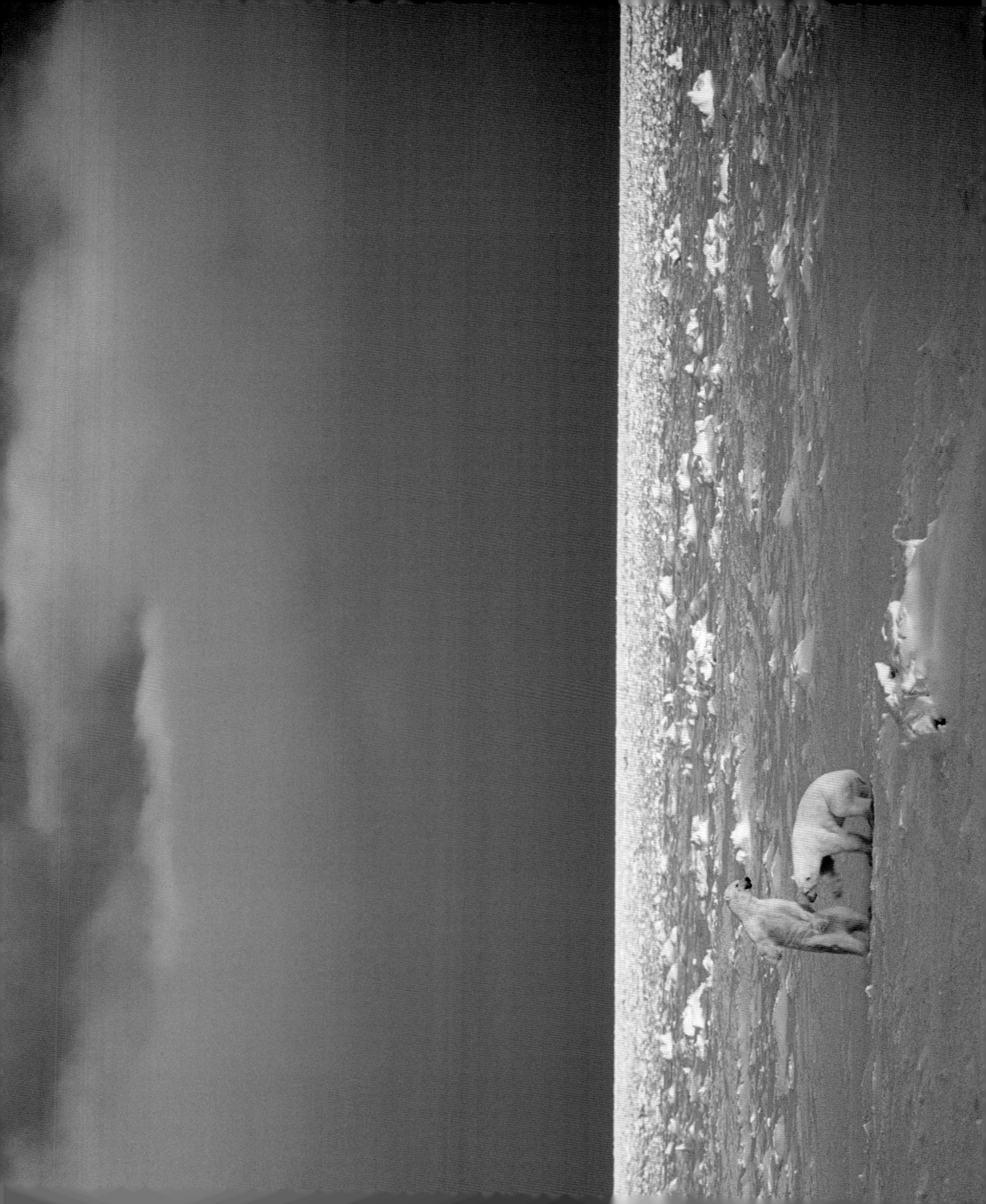

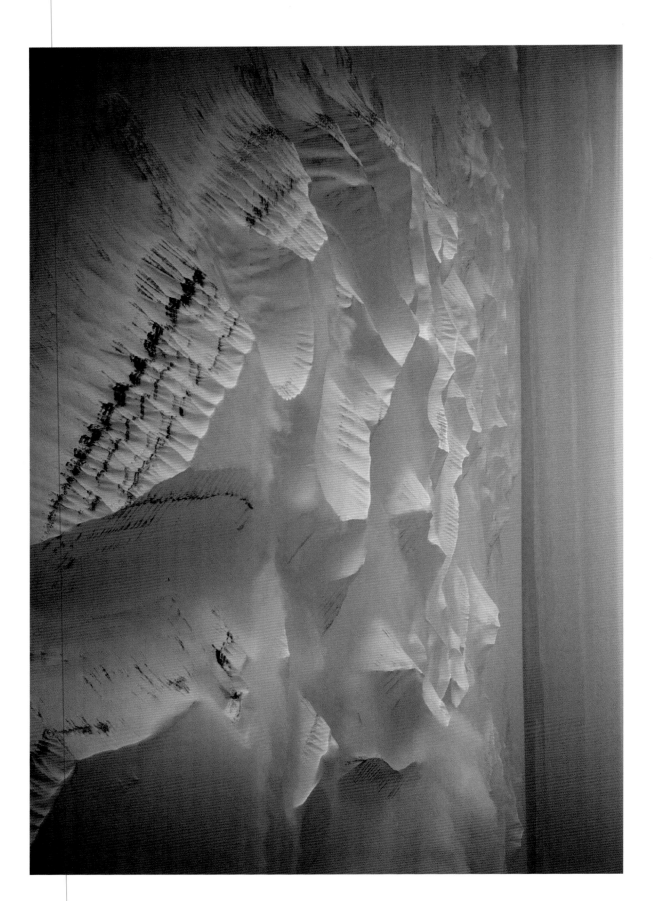

West Spitsbergen, Svalbard, from 15,000 feet.
> An iceberg stranded in the frozen Barents Sea off the coast of East Svalbard.
Following pages: Reindeer push through an extreme blizzard, East Svalbard.

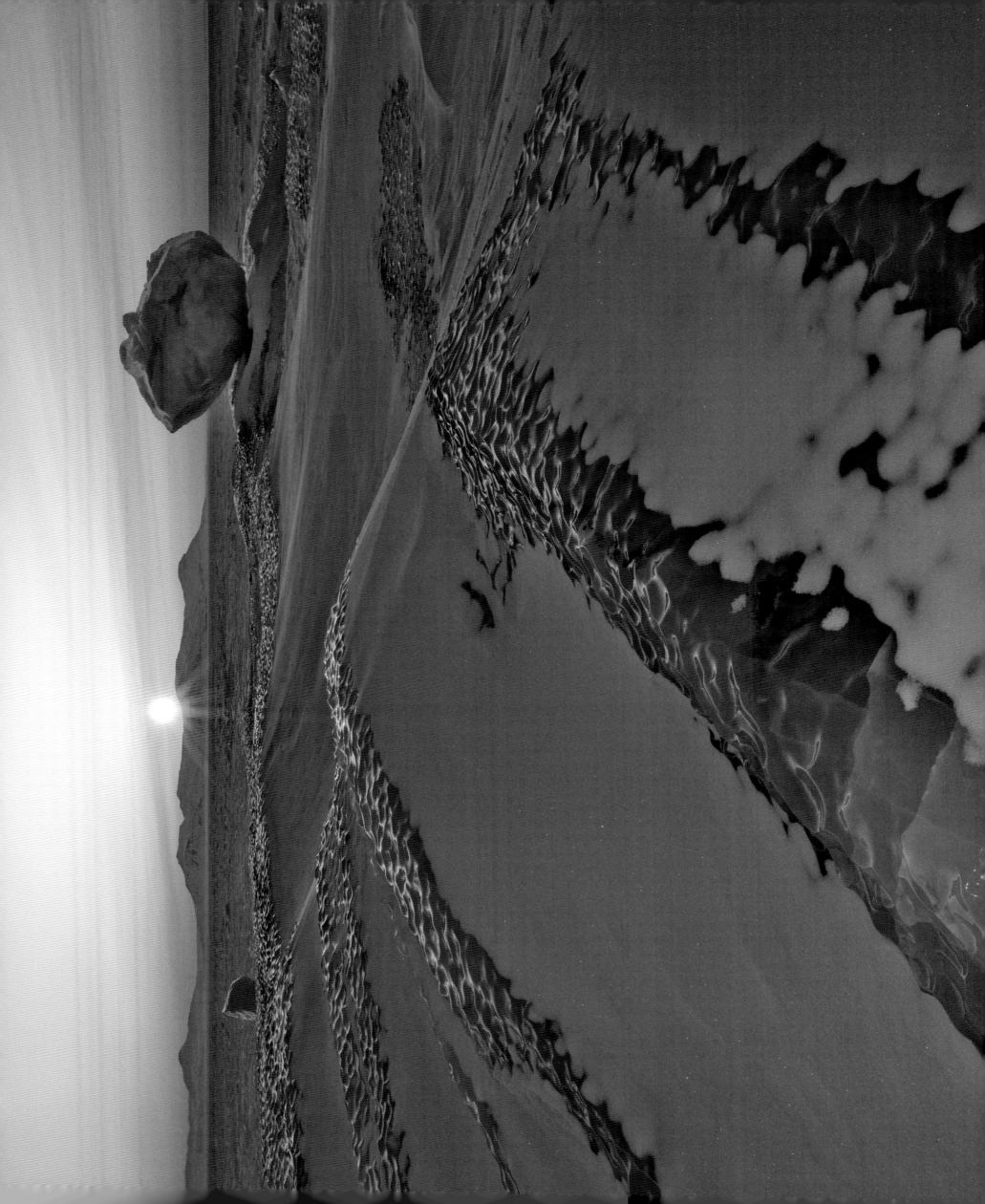

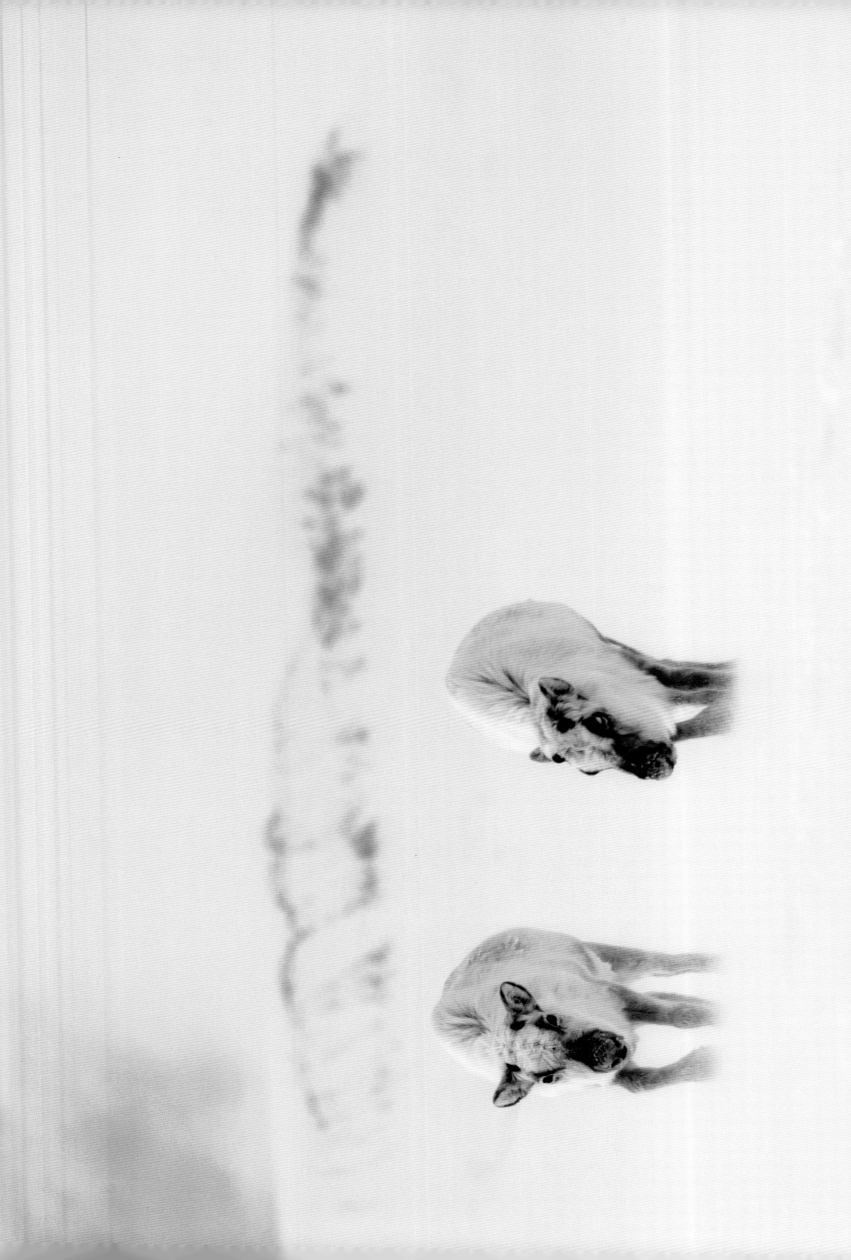

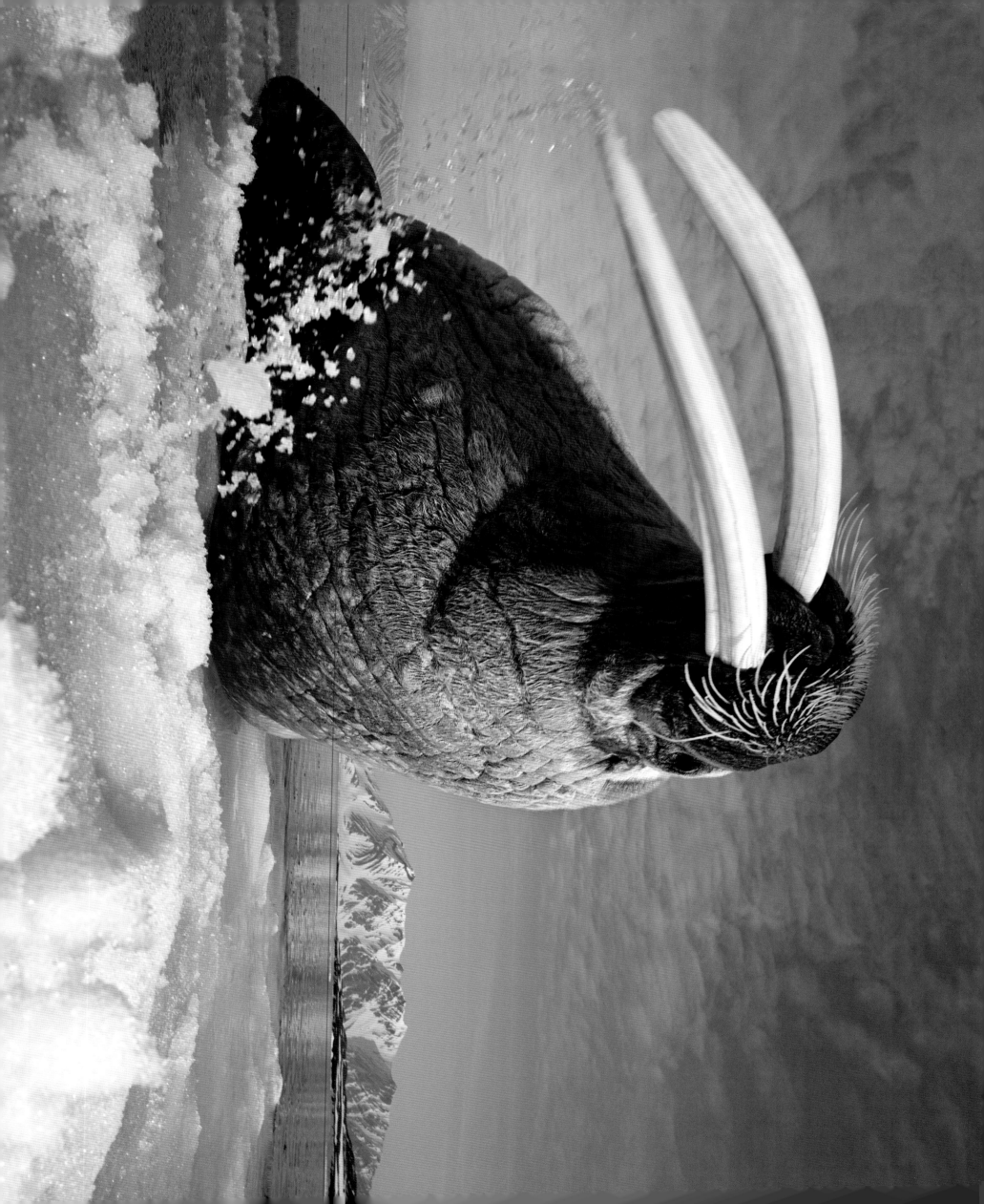

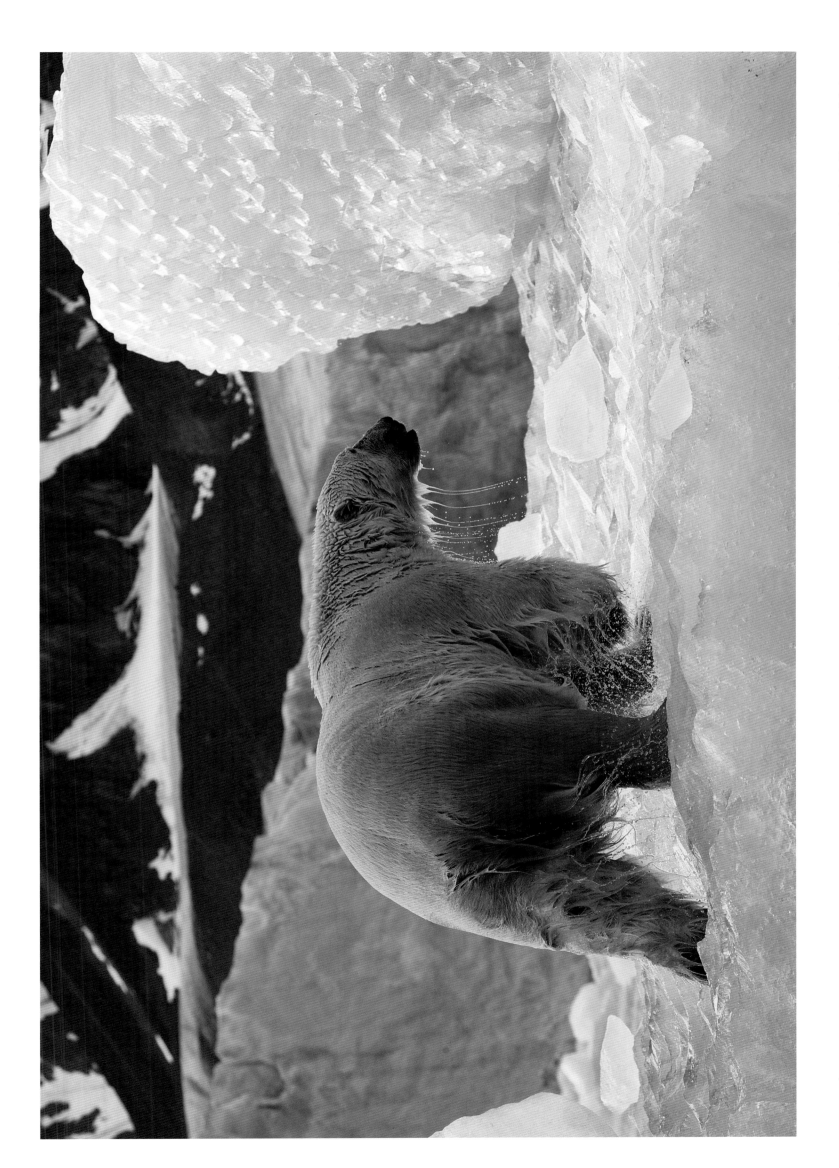

A male bear climbs onto freshly calved glacier ice in Hornsund, Spitsbergen.
< A walrus flicks his huge tusks, Bellsund, Spitsbergen.

125

A young bear carefully navigates a disintegrating ice pack off the northeast corner of Spitsbergen. Pack ice remains in the Arctic year-round, allowing bears, seals, walruses, and zooplankton to maintain life. However, the pack ice, once projected to disappear in the next 50 to 100 years, is now expected to melt within 7 to 20 years. This will have very serious effects on many polar species. The polar bear is at risk of becoming extinct within 100 years because, without ice, the animals cannot hunt efficiently.

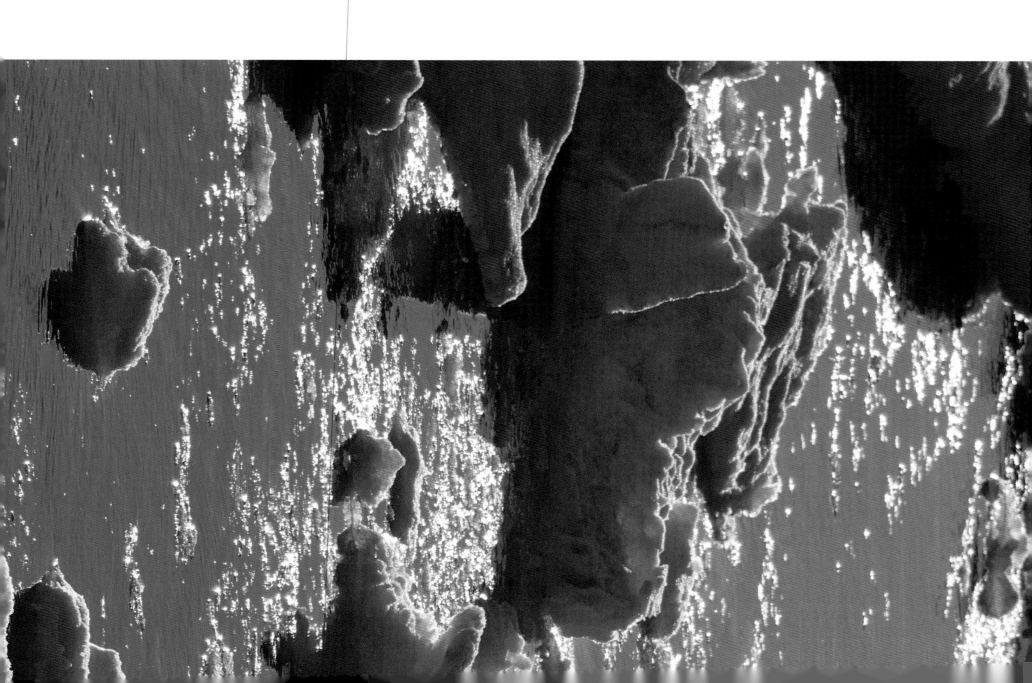

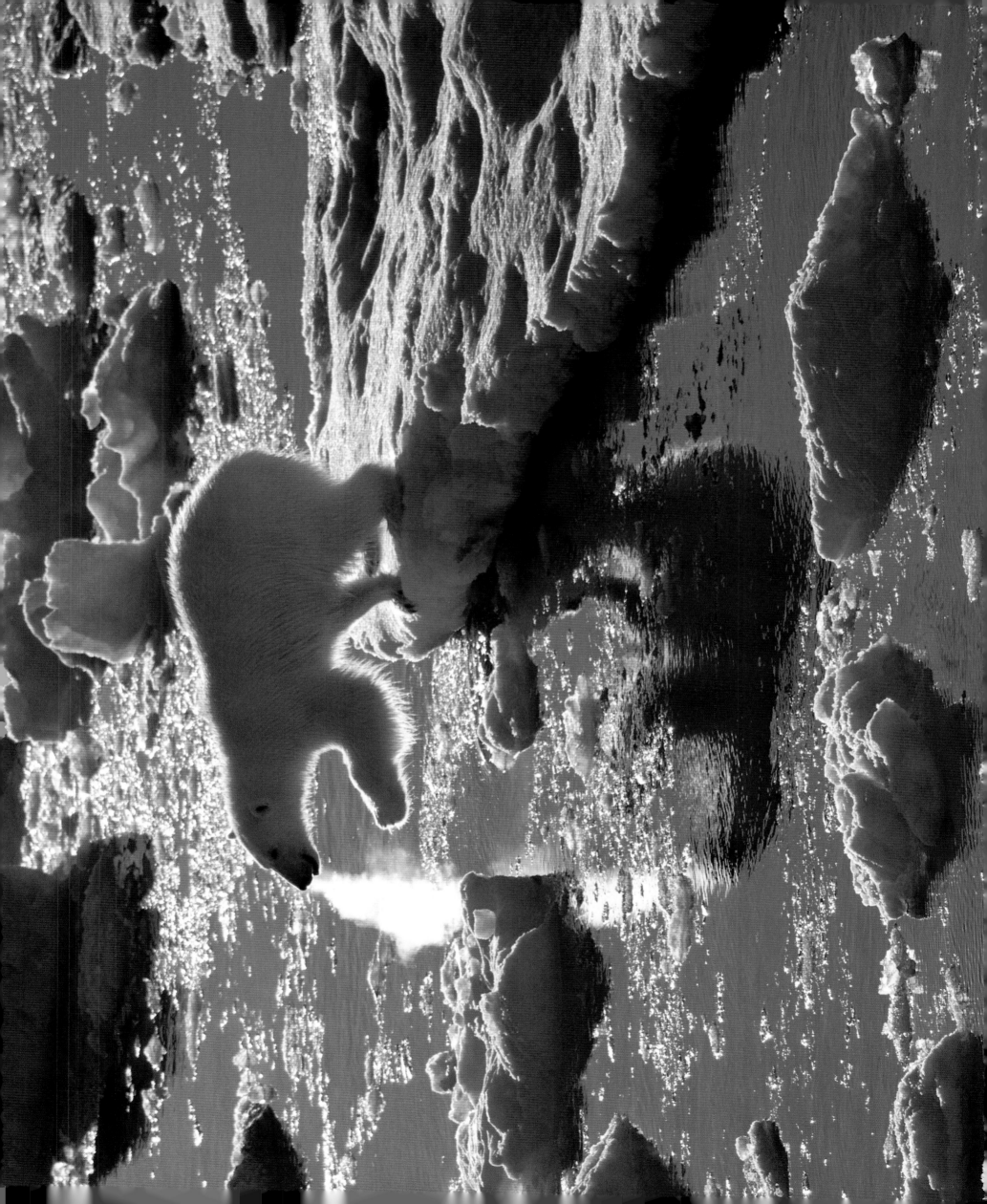

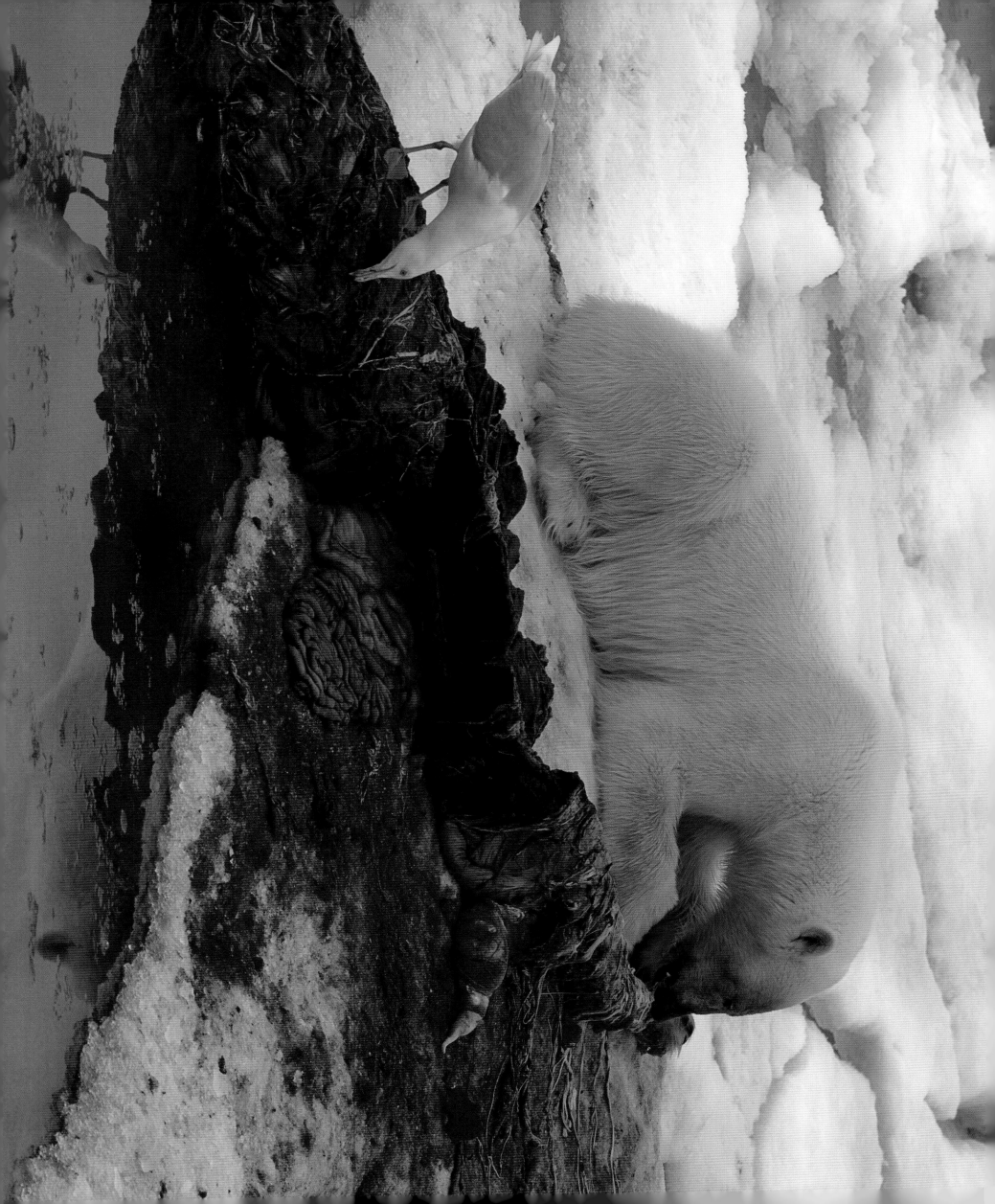

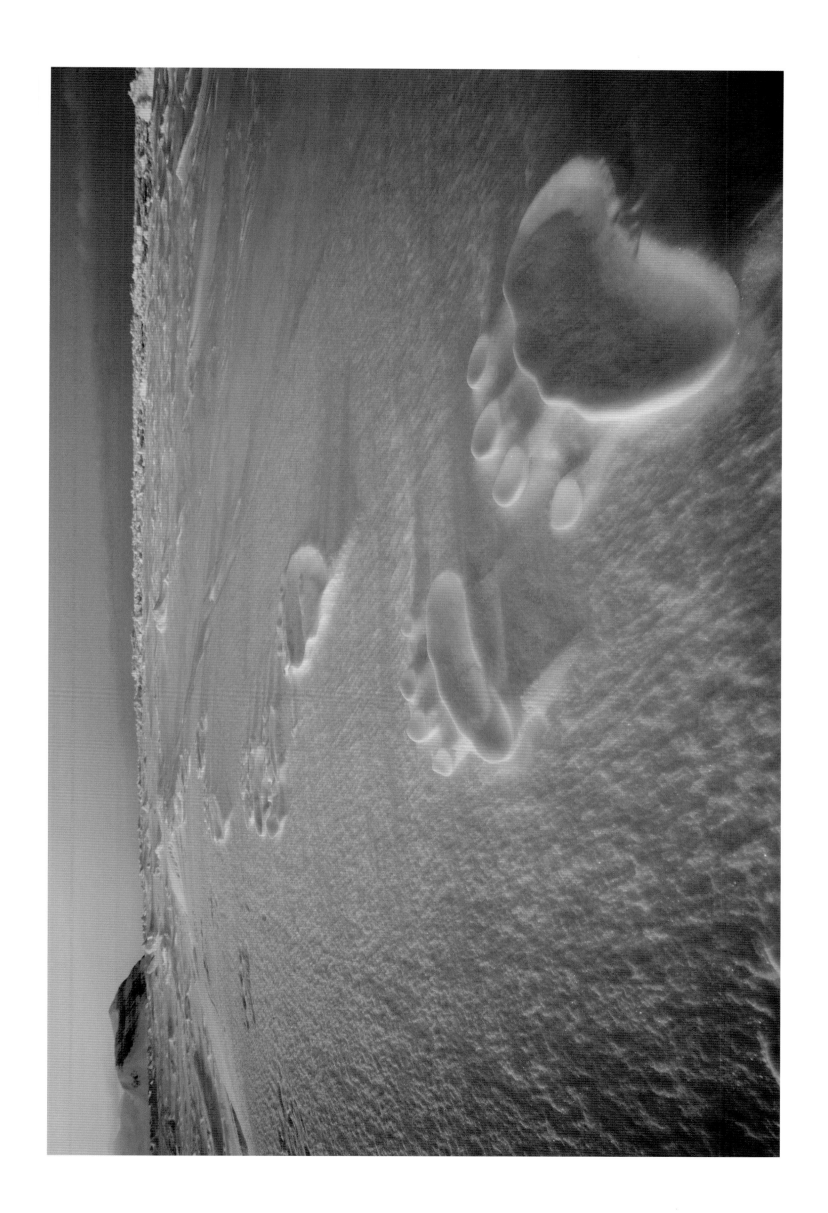

Polar bear tracks on sea ice, East Svalbard.
< A polar bear eating a beluga whale, North Spitsbergen.

129

A large male polar bear feeding on the ribs of a bearded seal, Leifdefjorden, Spitsbergen.

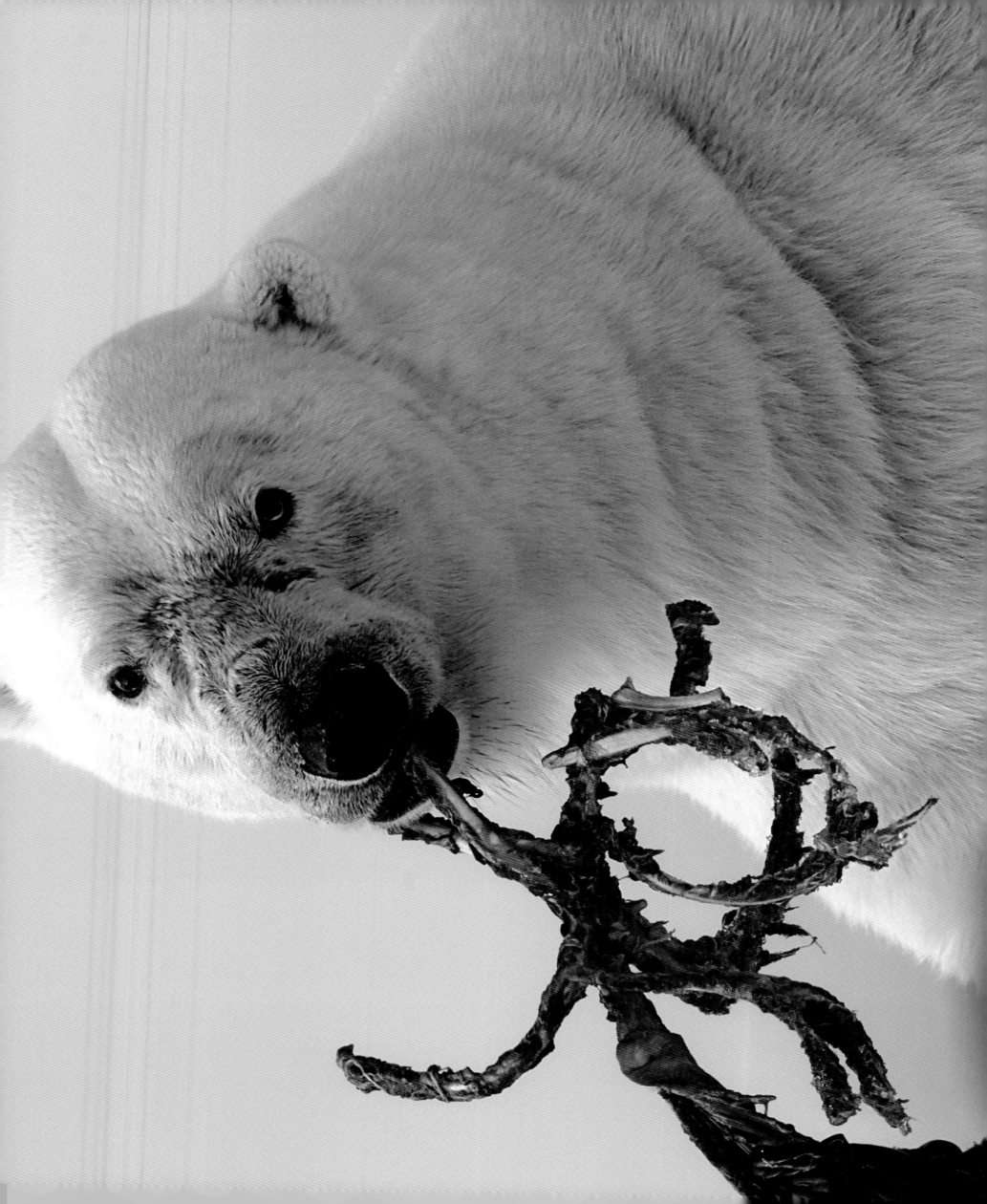

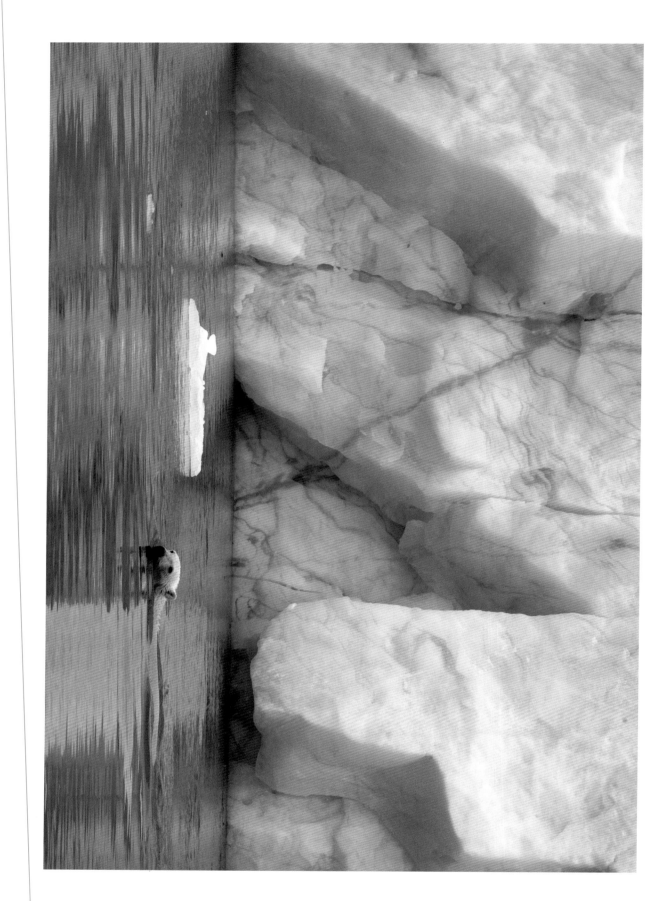

A polar bear swims in front of a glacier, Burgerbukta, Hornsund.

> Nordaustlandet ice cap gushes water during the warmer summer months.

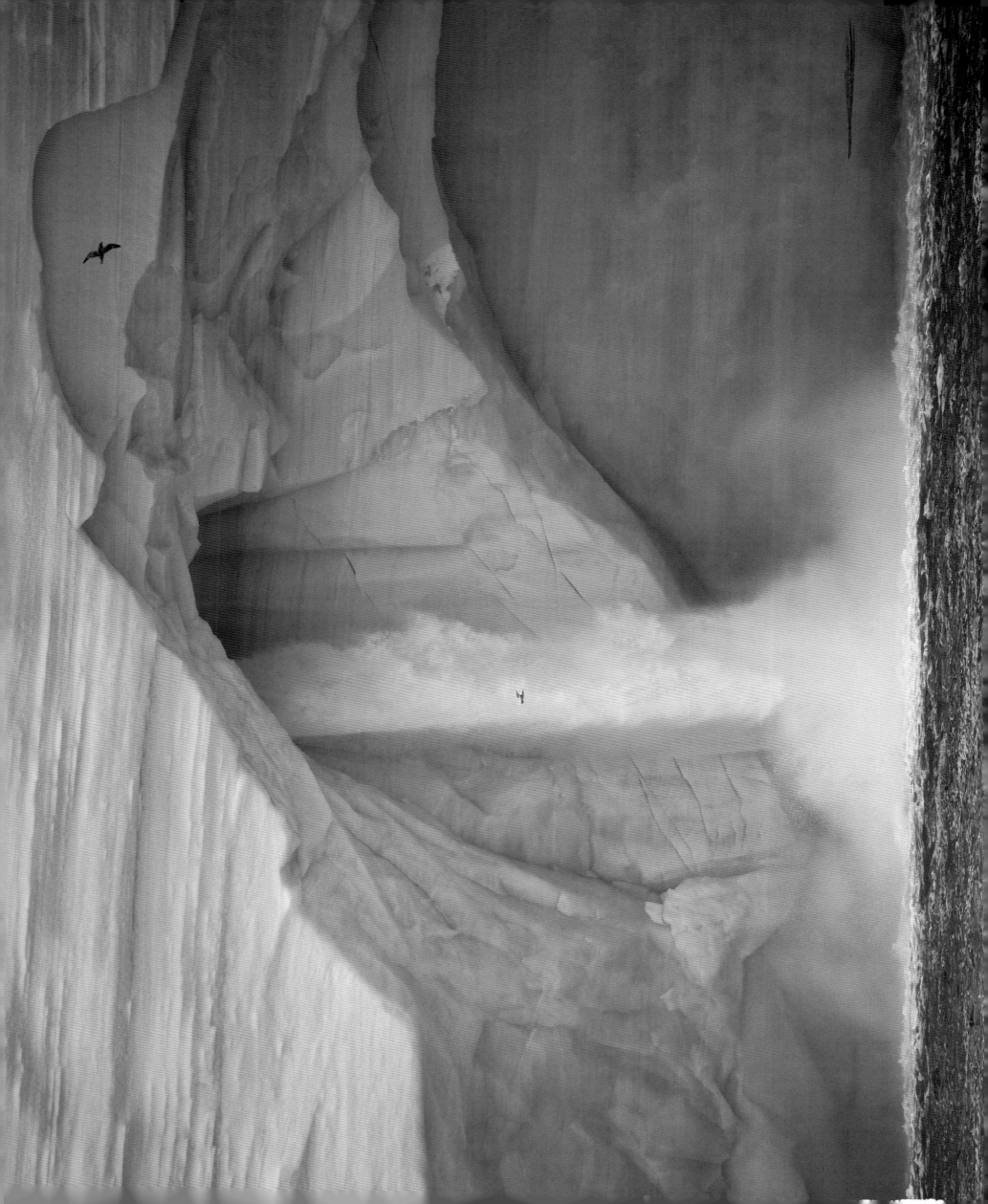

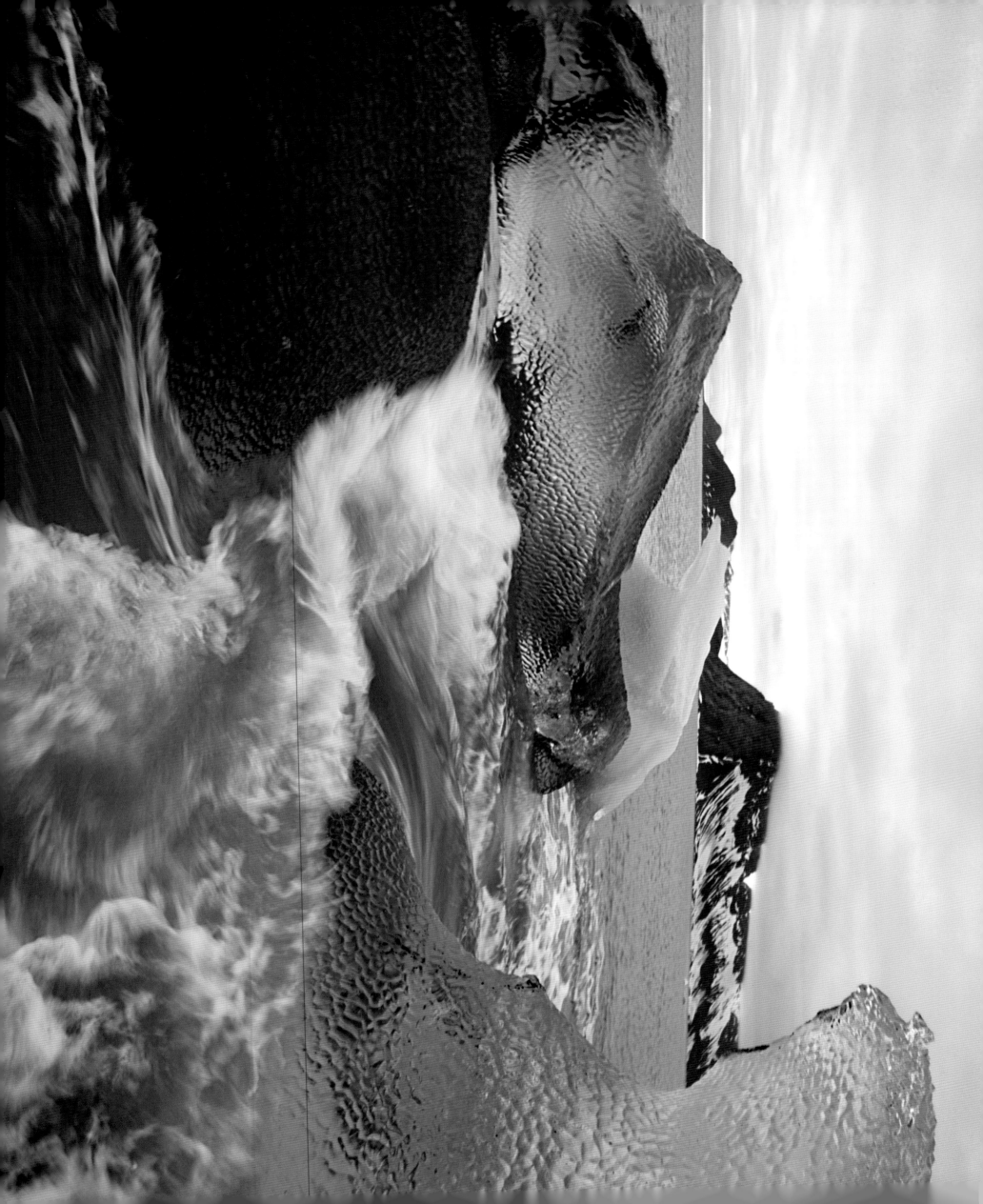

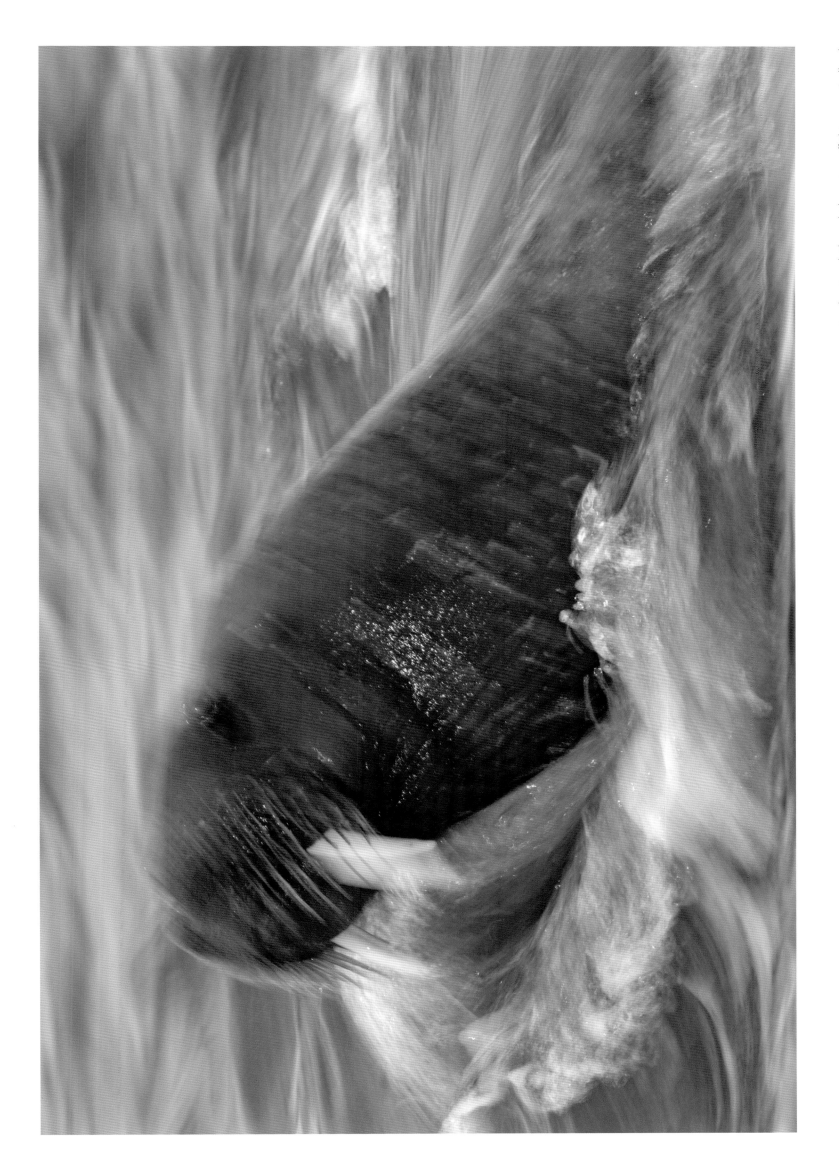

A walrus travels through the waters off Phippsøya, Svalbard.
< Waves flush through disintegrating glacier ice, Hornsund.

A bearded seal rides a freshly calved piece of glacier ice, West Spitsbergen.

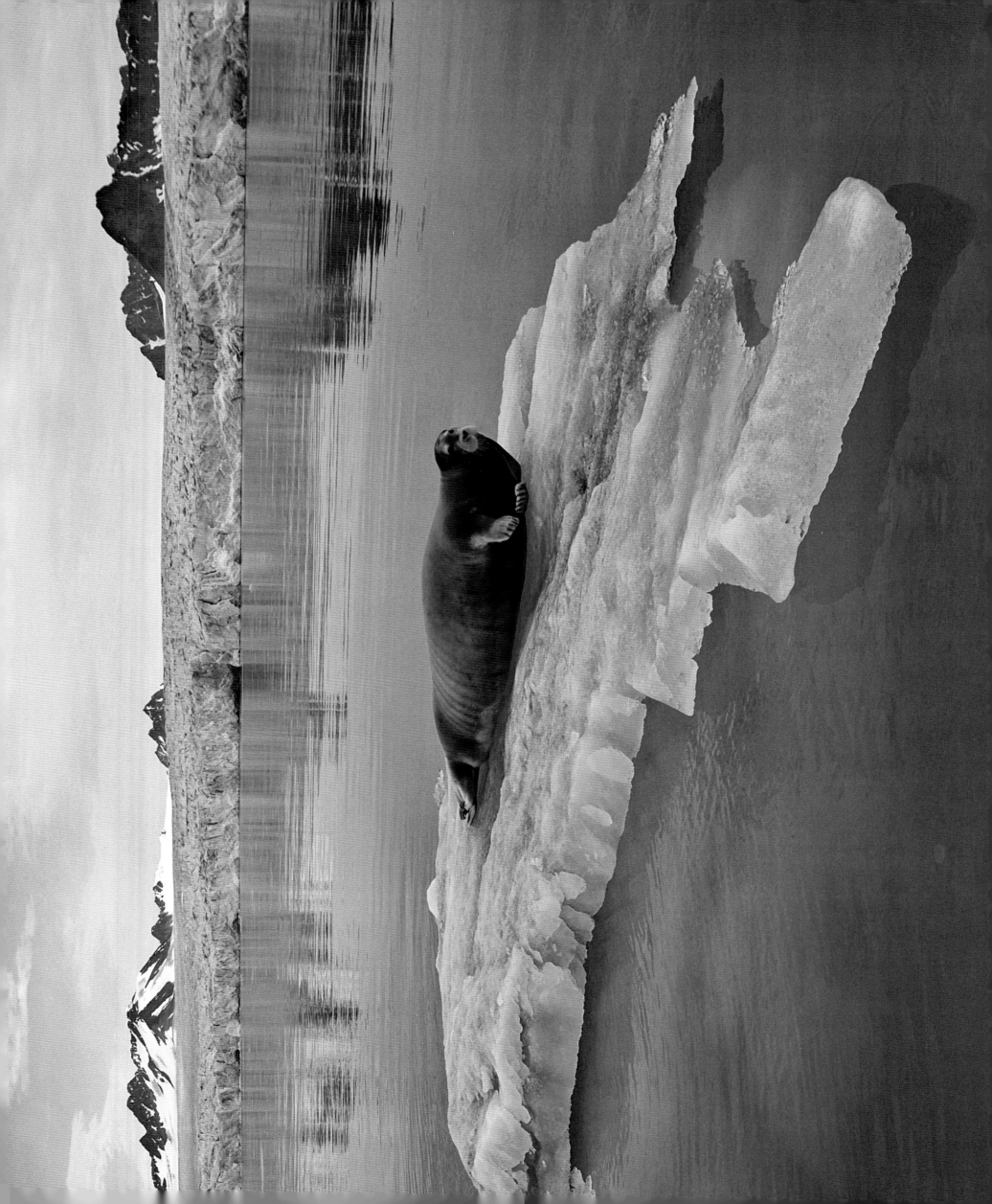

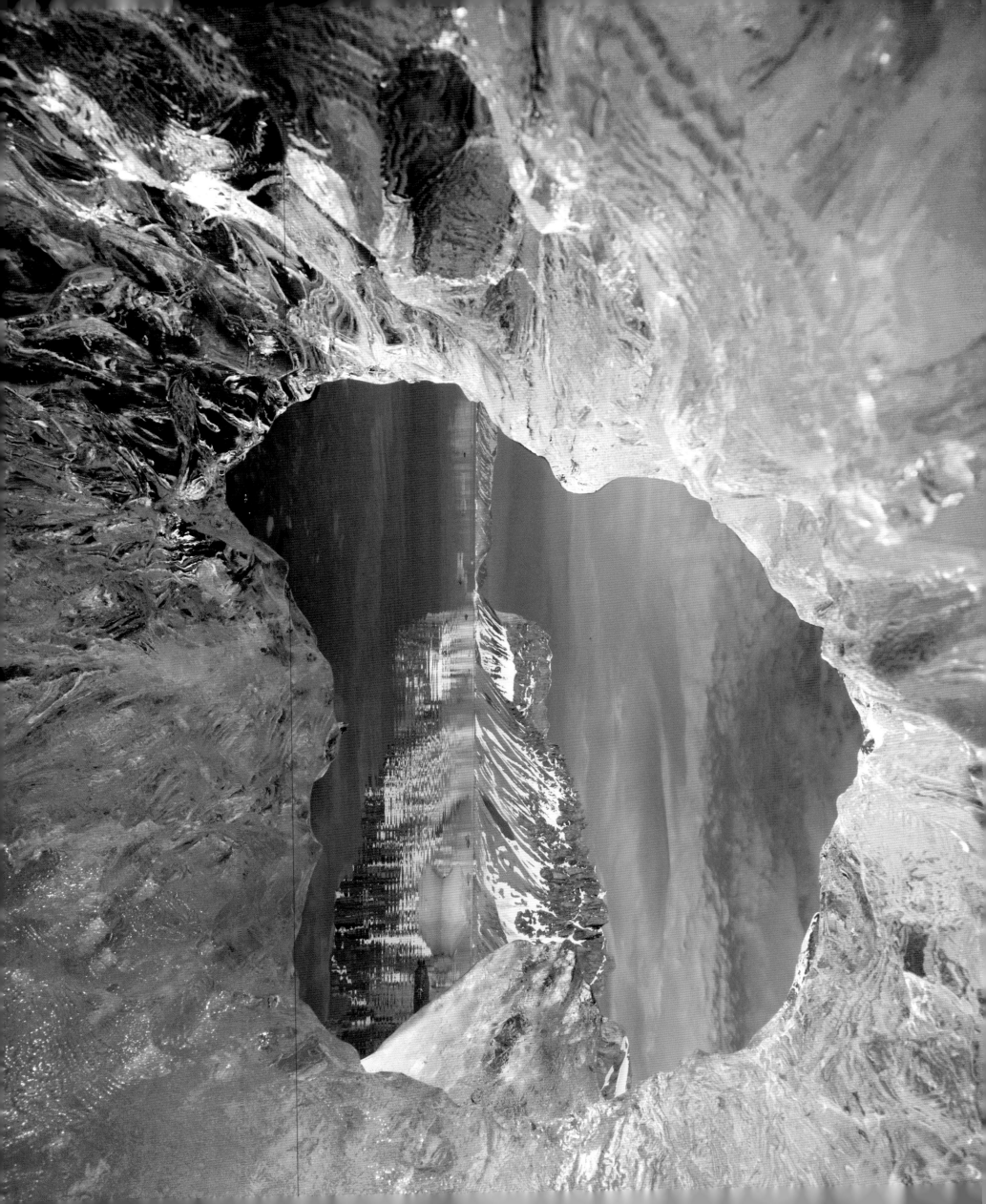

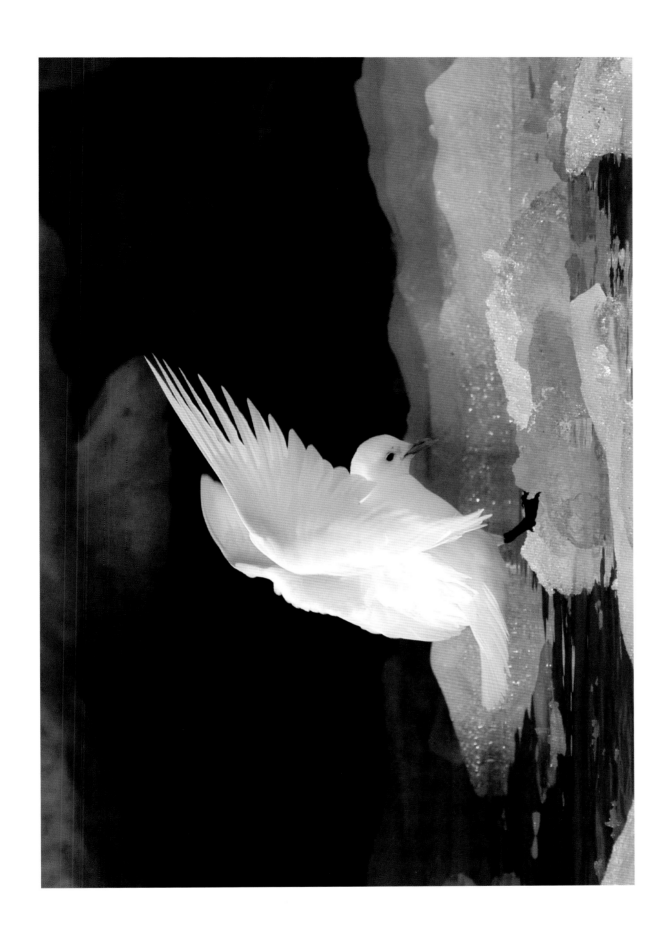

An ivory gull searches for nutrients on ice, Hornsund.
< Hornsund through the eye of glacier ice.

139

A female polar bear and her two cubs, just seven months old, stand along basalt shores of Spitsbergen. Cubs this young are not yet expert swimmers and cannot remain in the cold water for long periods of time. Unlike other locations in the Arctic, Svalbard has many glaciers, and bears can swim out to try and catch an unsuspecting seal off a piece of drifting glacier ice. However, the glaciers are rapidly receding, and such ice islands are becoming fewer. For a mother who needs nutrition to continue the energetic strain of nursing her two cubs, the inability to hunt efficiently from the ice can prove devastating.

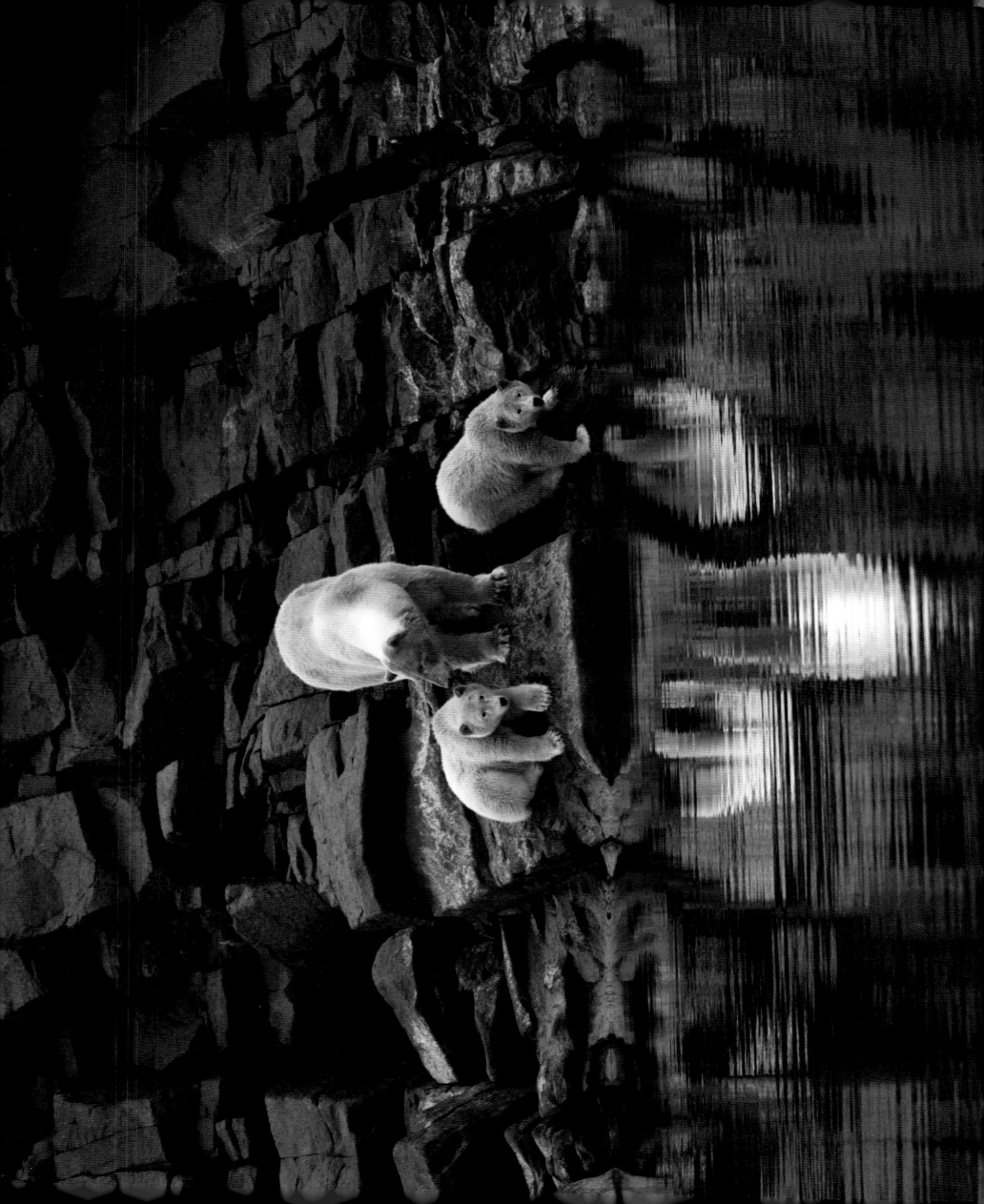

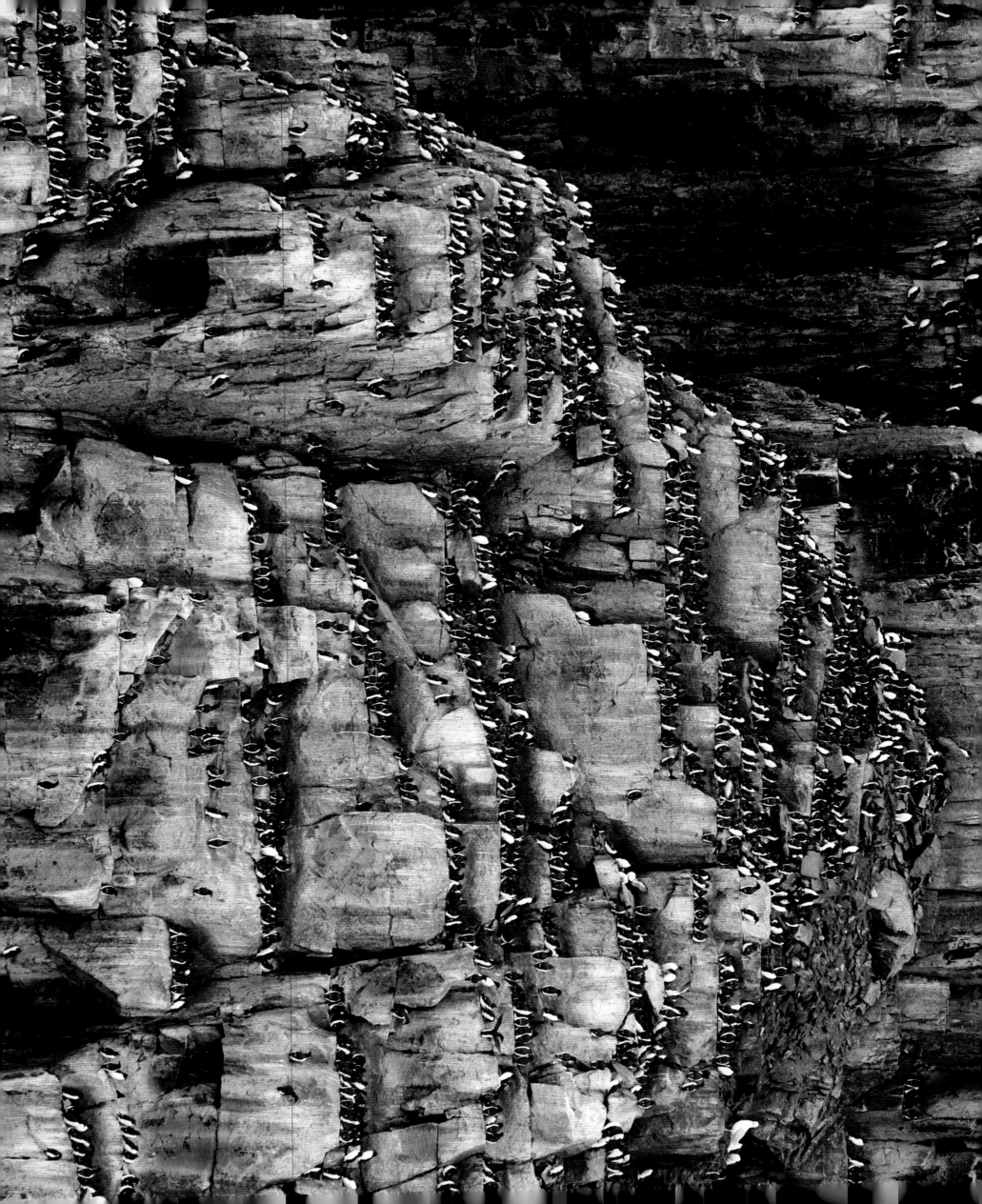

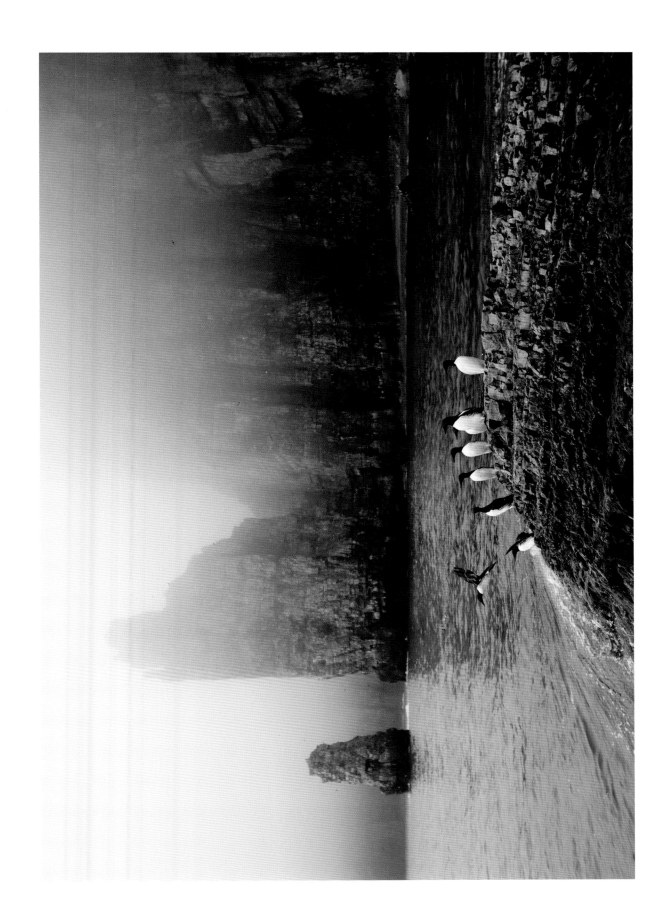

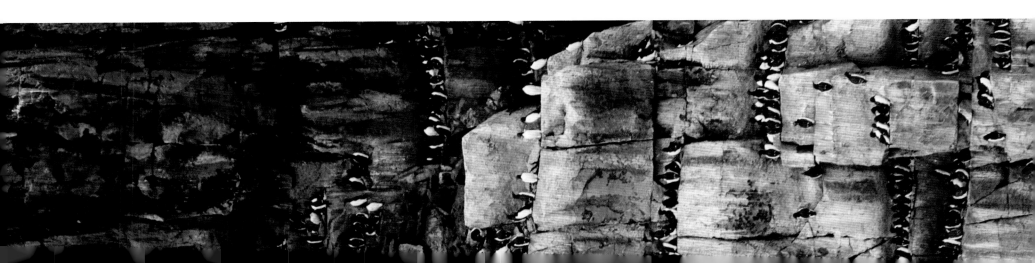

Brünnich's guillemots along the shore of Bjørnøya, Svalbard.
< Brünnich's guillemots nest in the millions along the shores of Cape Fanshawe, Spitsbergen.

Millions of little auks, also known as dovekies, arrive at the shores of Svalbard each spring to nest and feed on the ocean's bounty of copepods. The steep rocky slopes provide the perfect nesting habitat where the birds raise their chicks in underground rocky burrows. As the parents arrive back from the sea every day with bellies and throat pouches full of copepods, their guano falls to the ground at the base of the nesting colony, fertilizing the tundra and providing essential nutrition to species such as reindeer, geese, and other ground-nesting birds. All of the nutrient recycling creates a rich mini-oasis on this desert-like land of rock and ice.

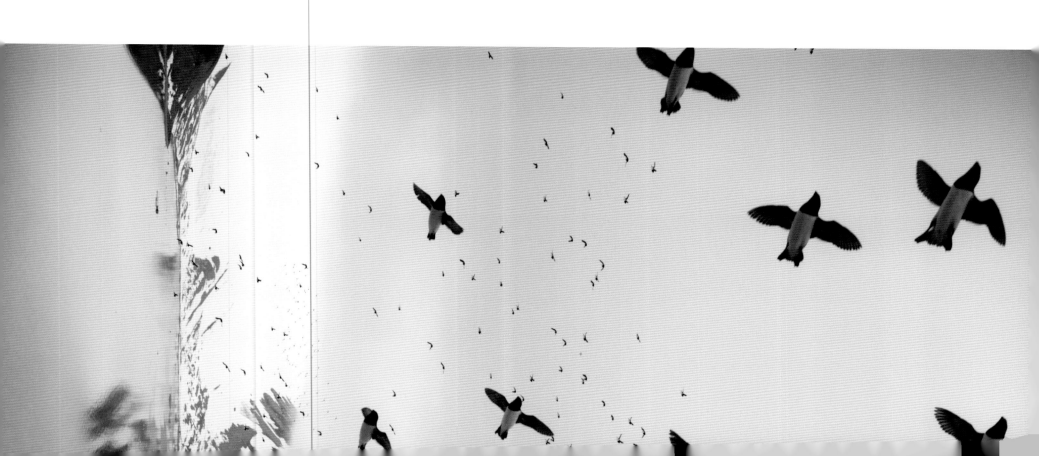

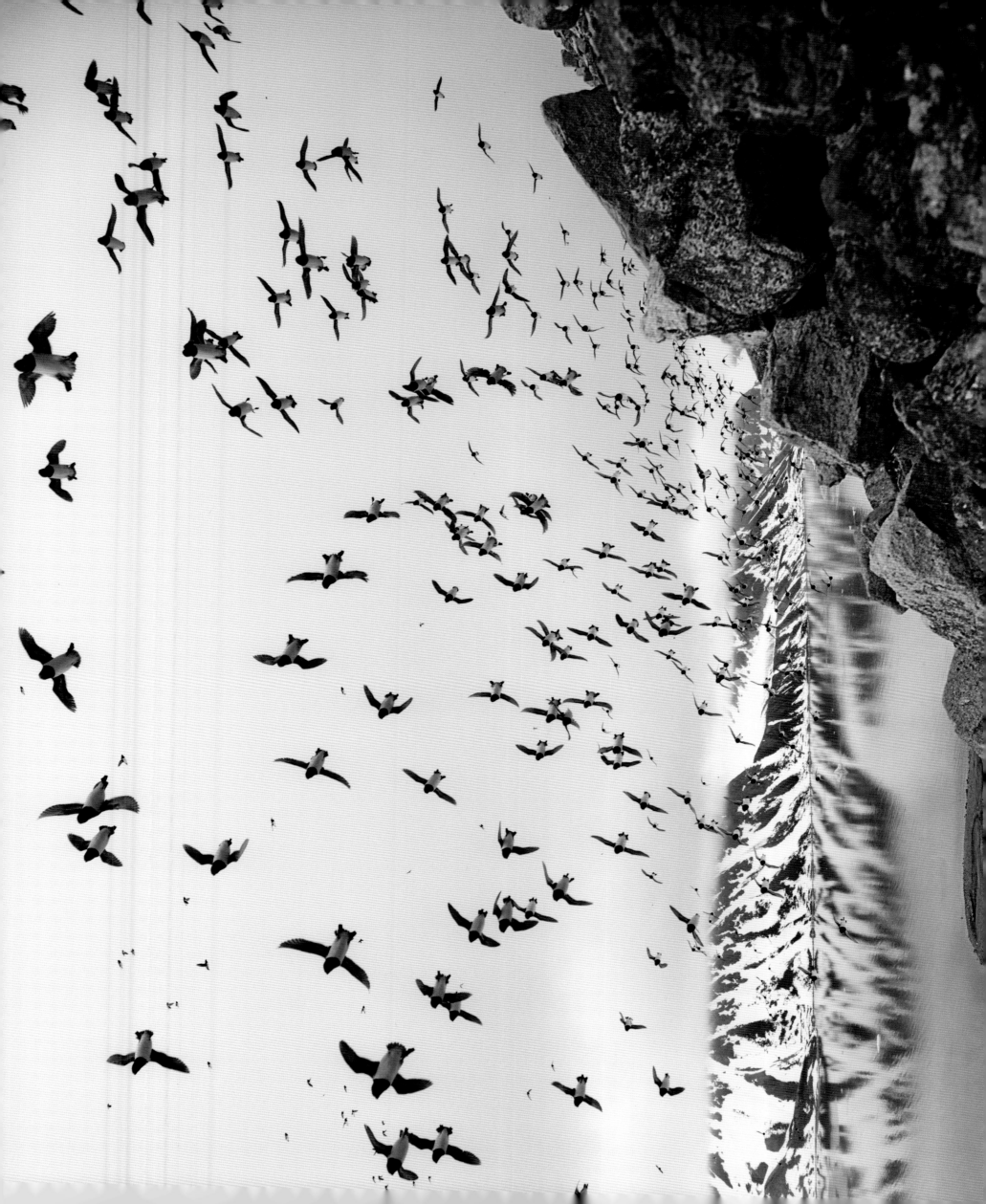

> A reindeer races across the sphagnum moss–covered tundra, Hornsund.

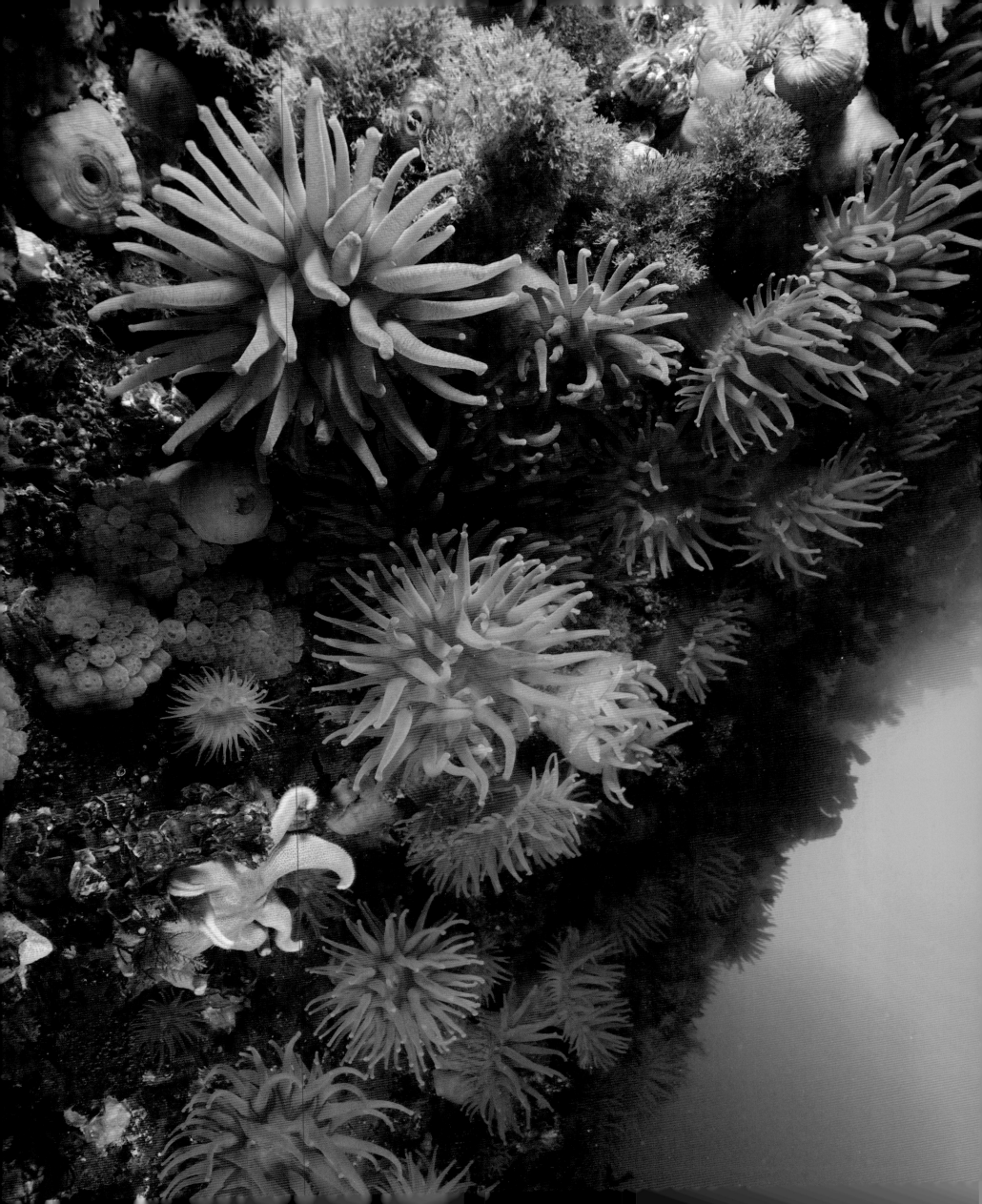

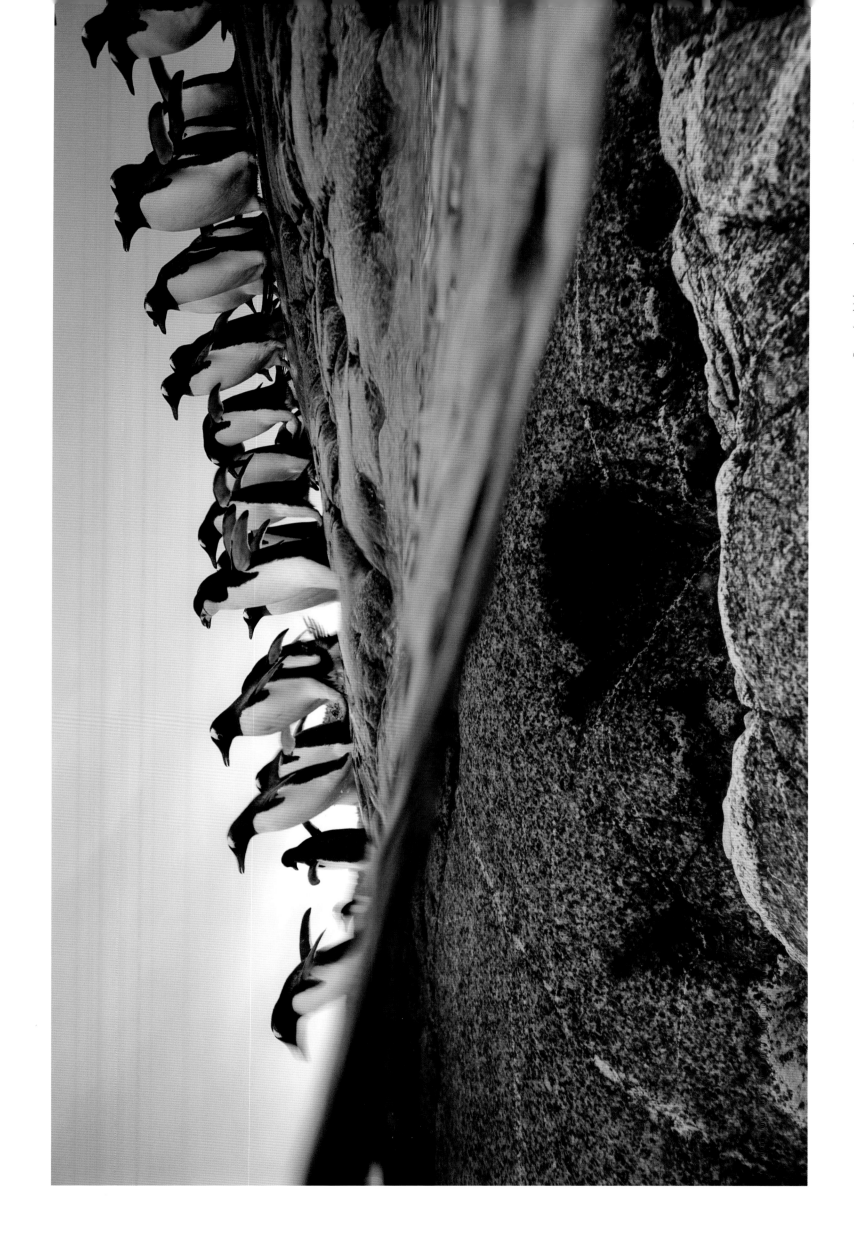

Penguin chicks race to the sea en masse, Anvers Island.
< A gentoo penguin chick peeks, checking for patrolling leopard seals before tempting fate, Port Lockroy.

167

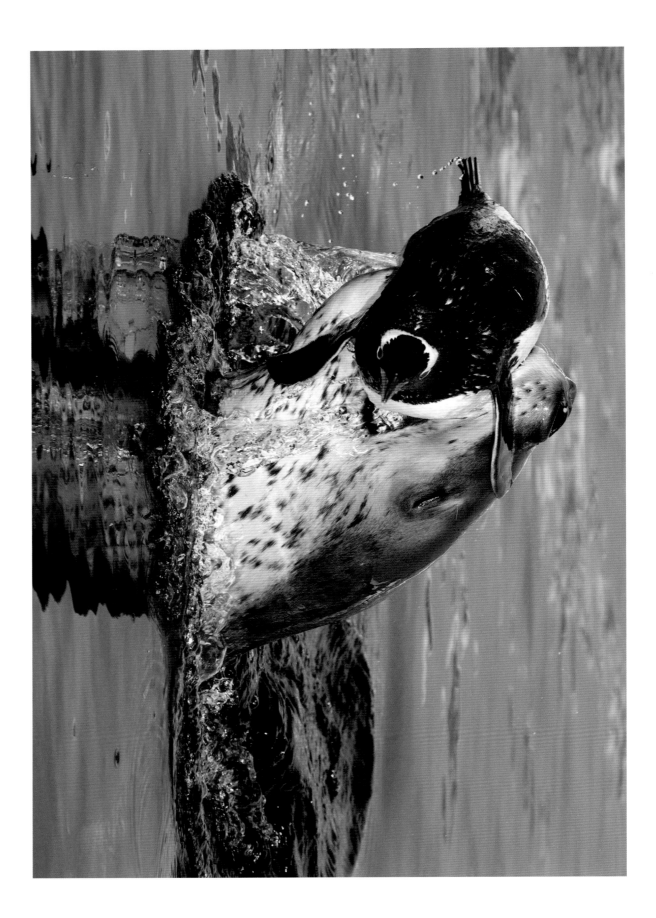

A gentoo penguin in the mouth of a leopard seal, Pleneau.

> The female leopard seal turns a penguin inside out to get to the meat, Anvers Island.

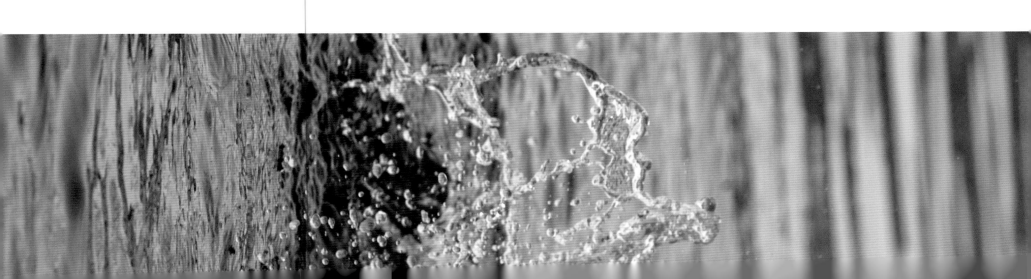

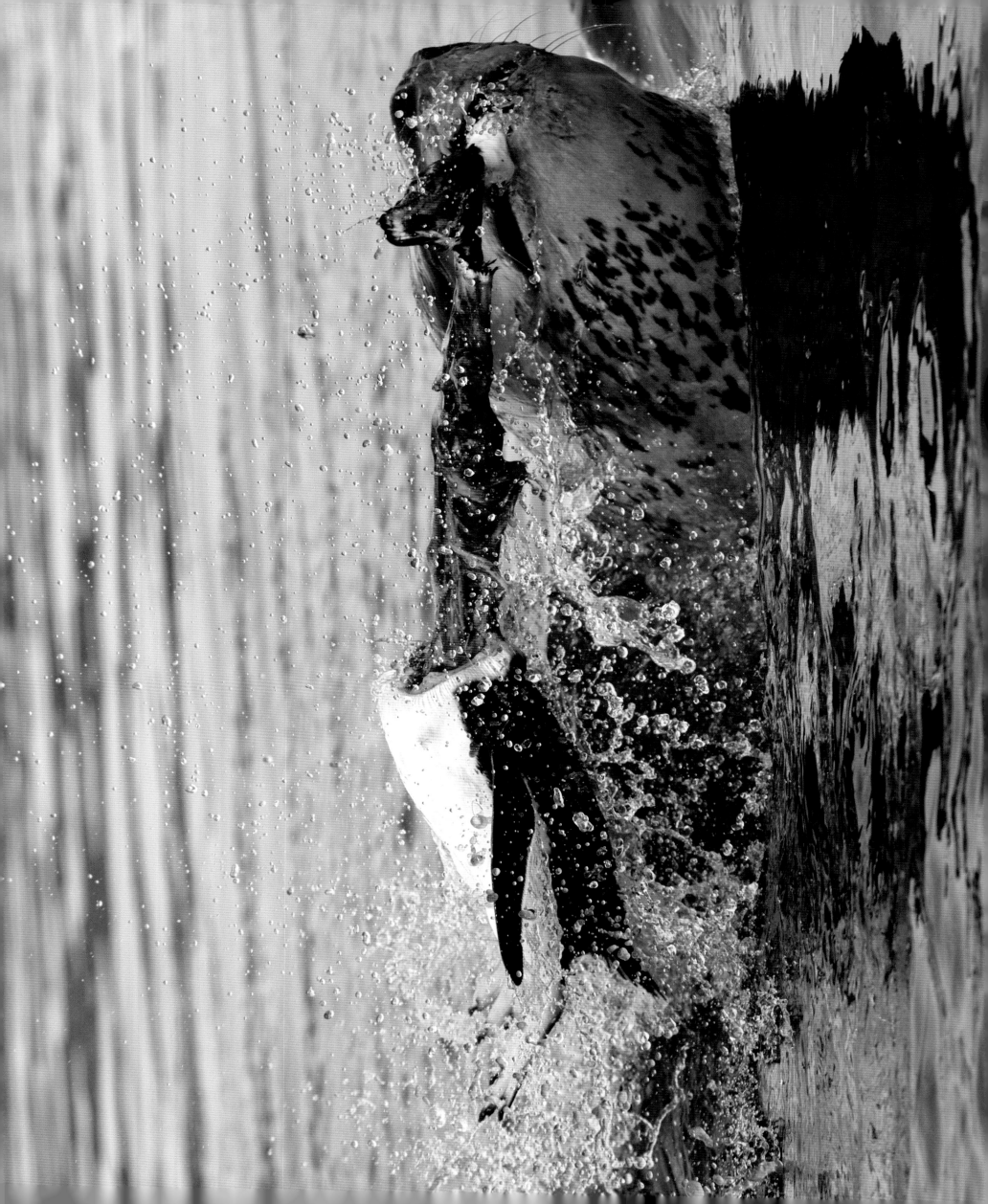

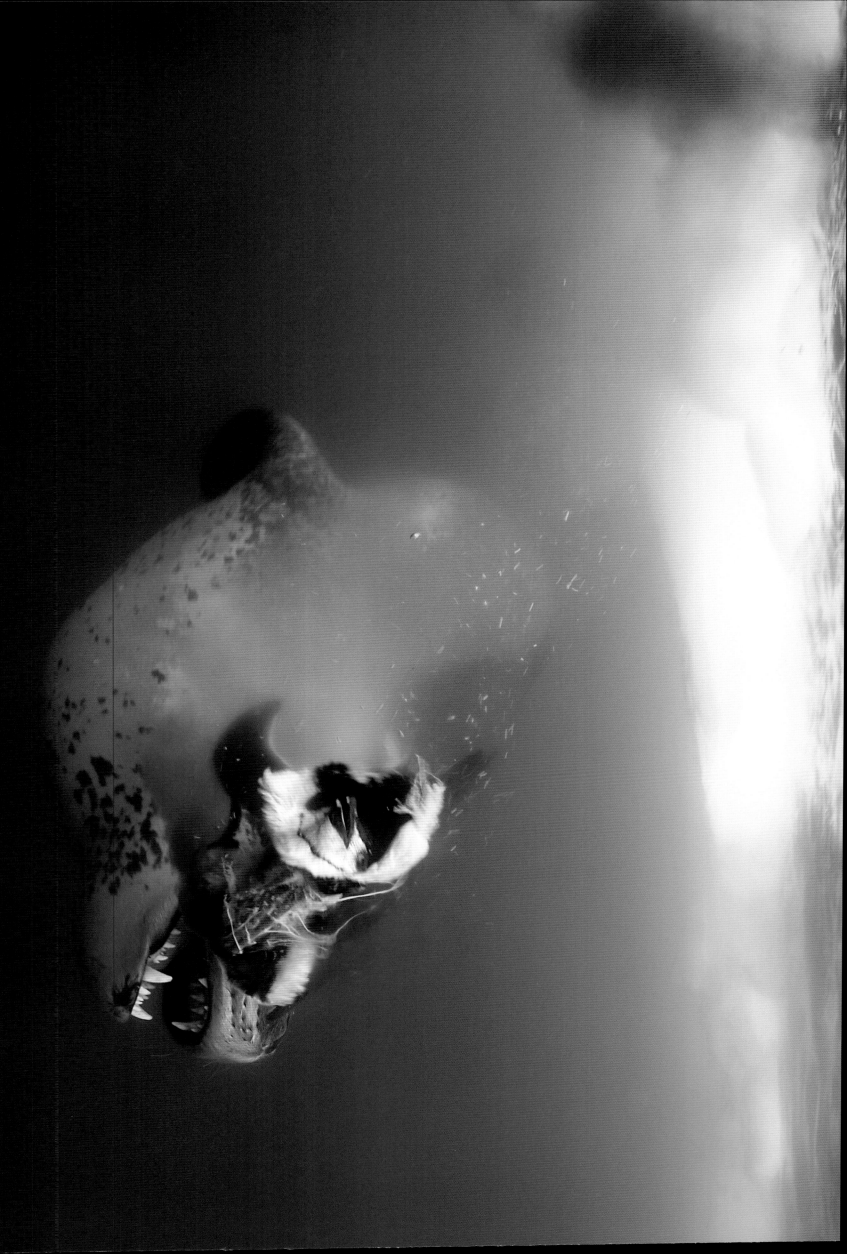

The leopard seal consumes a penguin chick, Anvers Island.

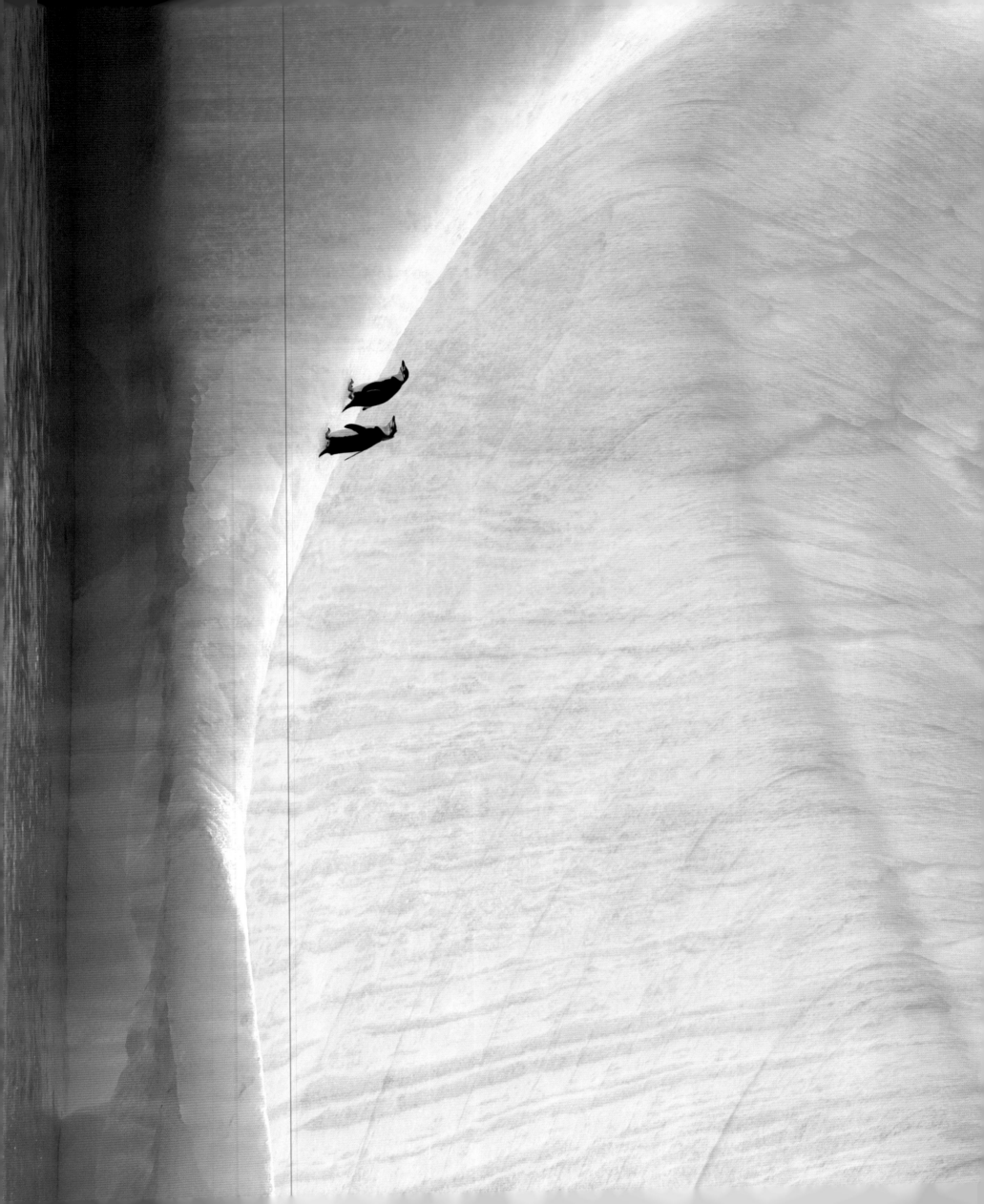

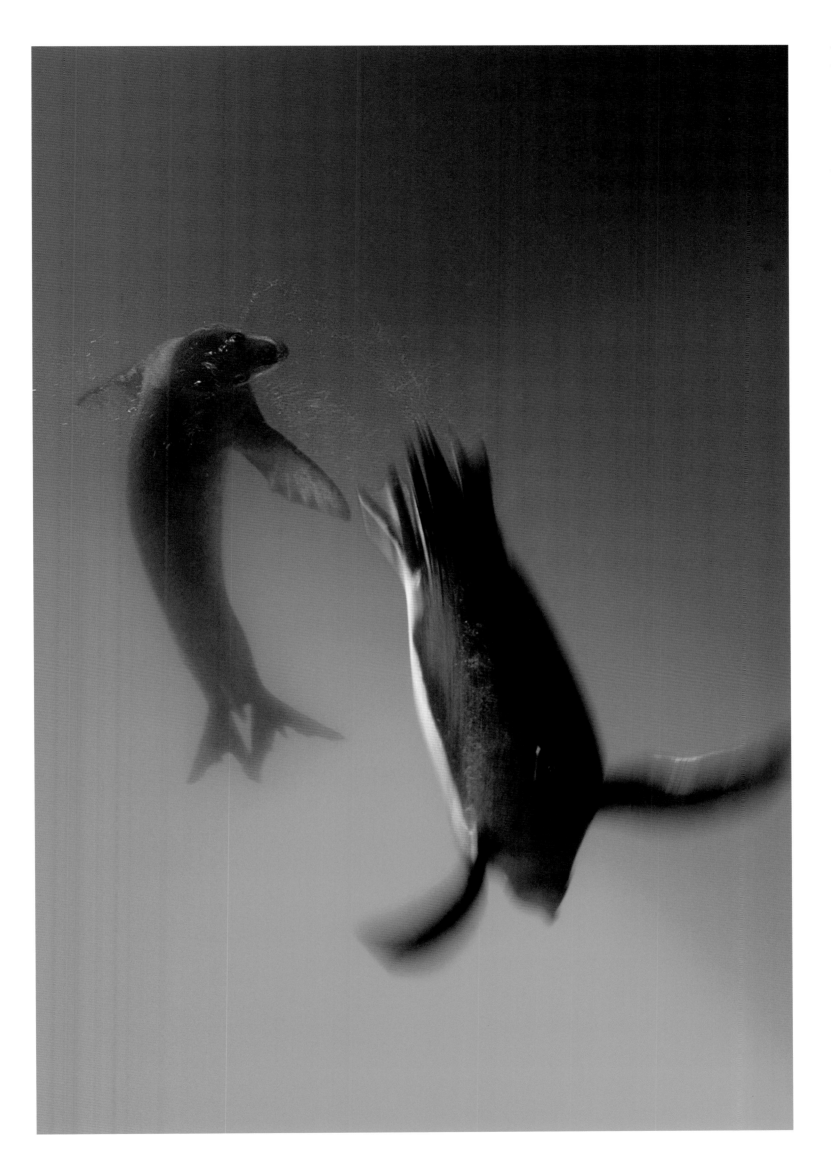

The large female leopard seal tries to feed me my first penguin, Anvers Island.
< Chinstrap penguin chicks rest on an iceberg, Anvers Island.

173

After the big female seal realized that I was unable to catch a swimming penguin, she tried different ways of presenting her offerings, elegantly moving toward me in different postures. The more I rejected her advances, the more frustrated she appeared. I was tempted to accept one of her gifts; however, the harder she tried, the more I got to shoot. She ate every penguin that I rejected, making sure to eat them right in front of me. It was difficult to watch the penguins slowly succumb to the leopard seal's emotionless ways. Regardless of whether they were trying to feed me or not, leopard seals appeared to enjoy playing with their catch before consuming them. Much of the year, leopard seals eat krill; however, when it is the time of year to gorge on penguin chicks, they can eat up to 15 penguins in a day.

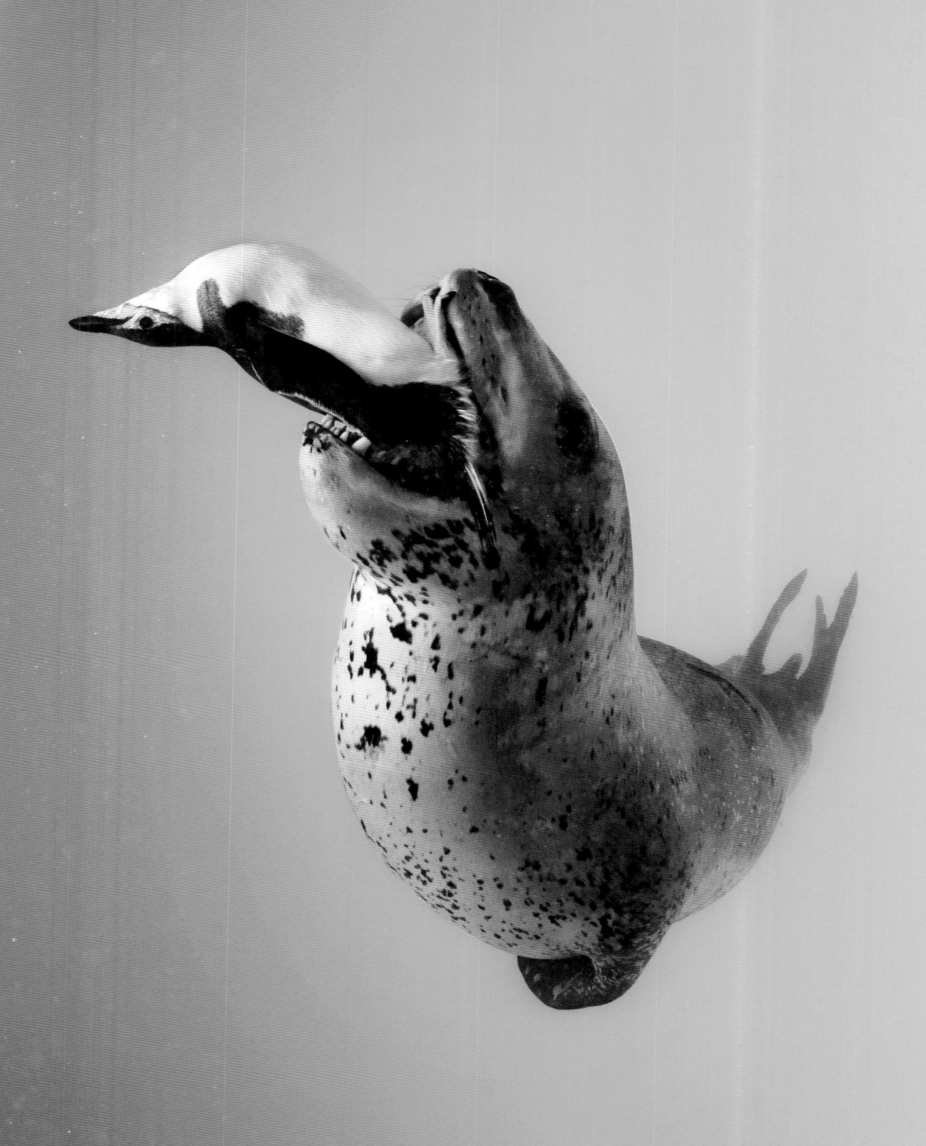

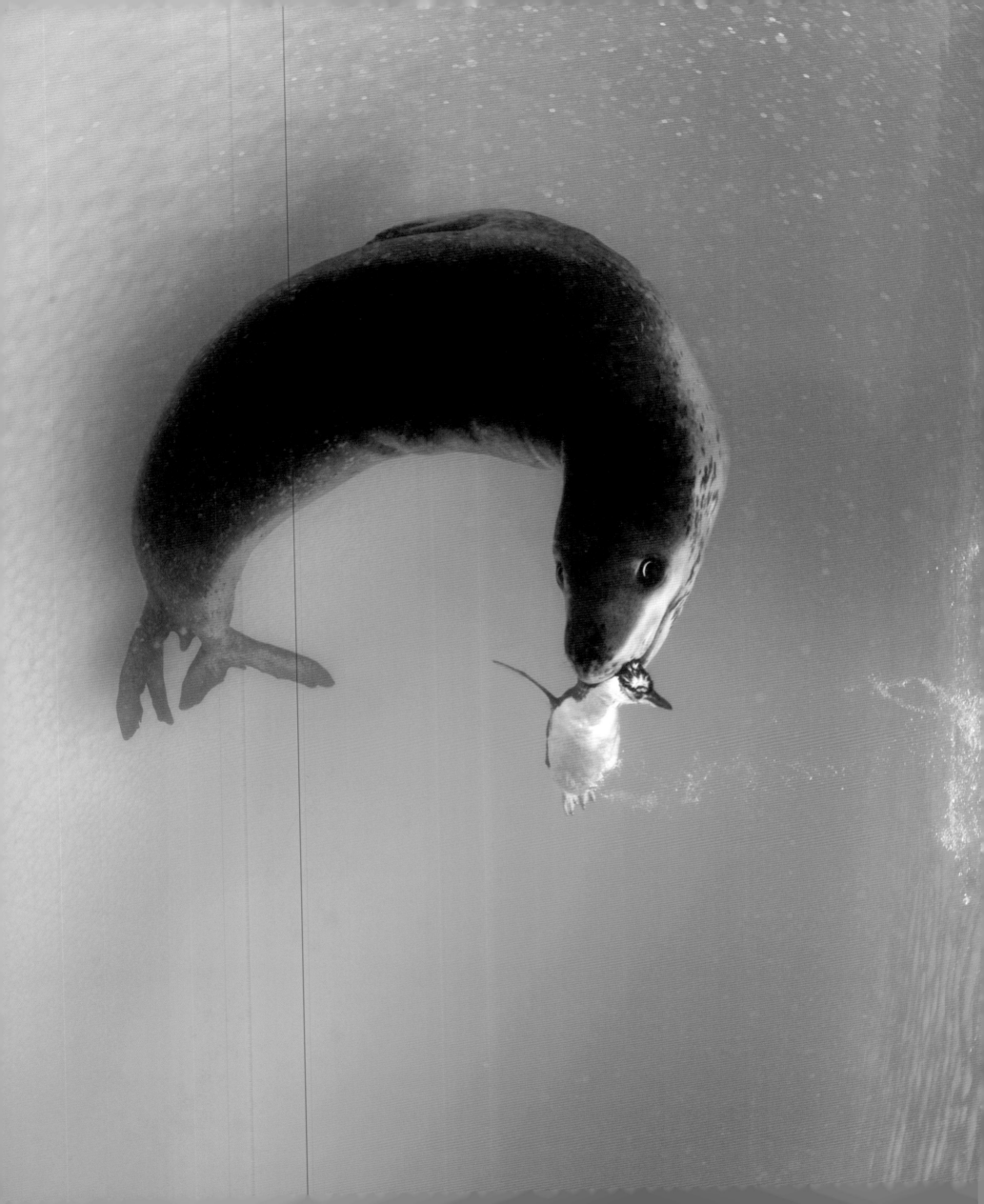

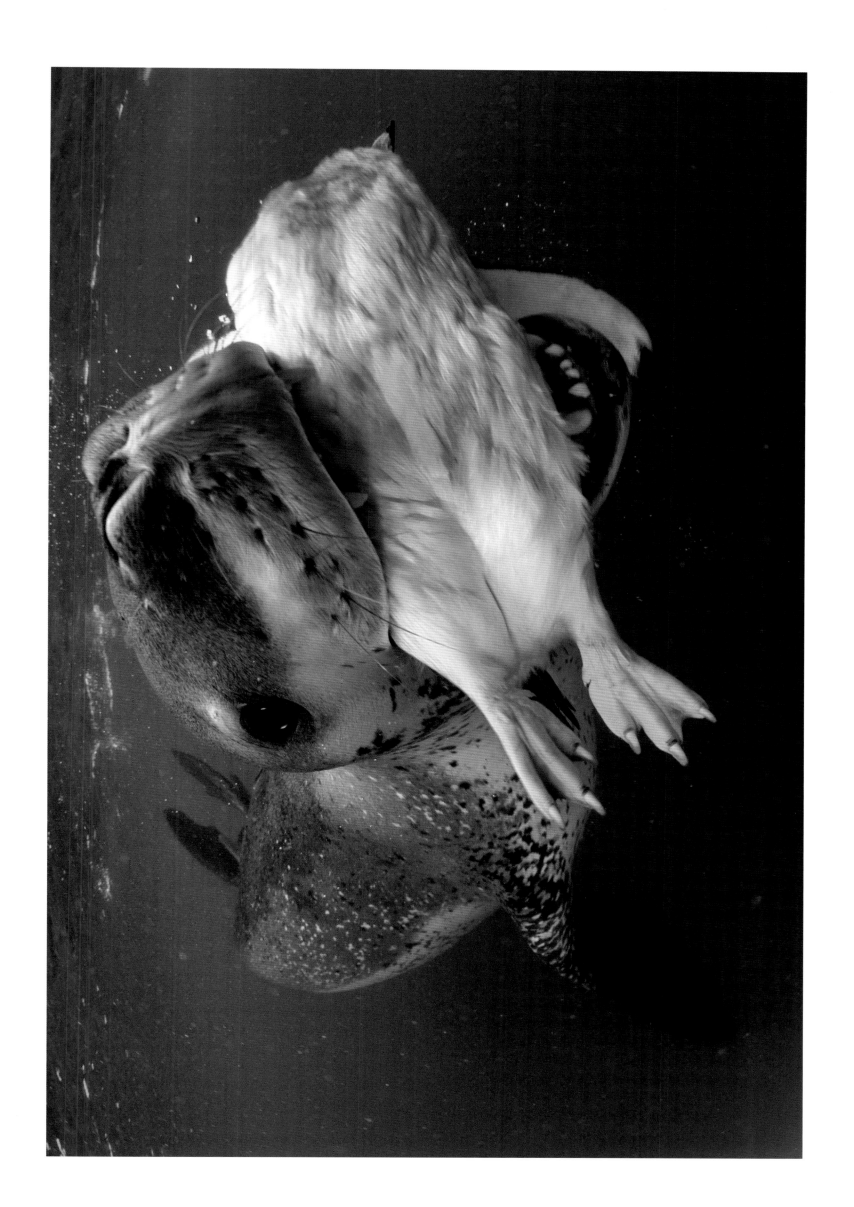

Above and opposite: She becomes more insistent in her efforts to feed me penguins, Anvers Island.

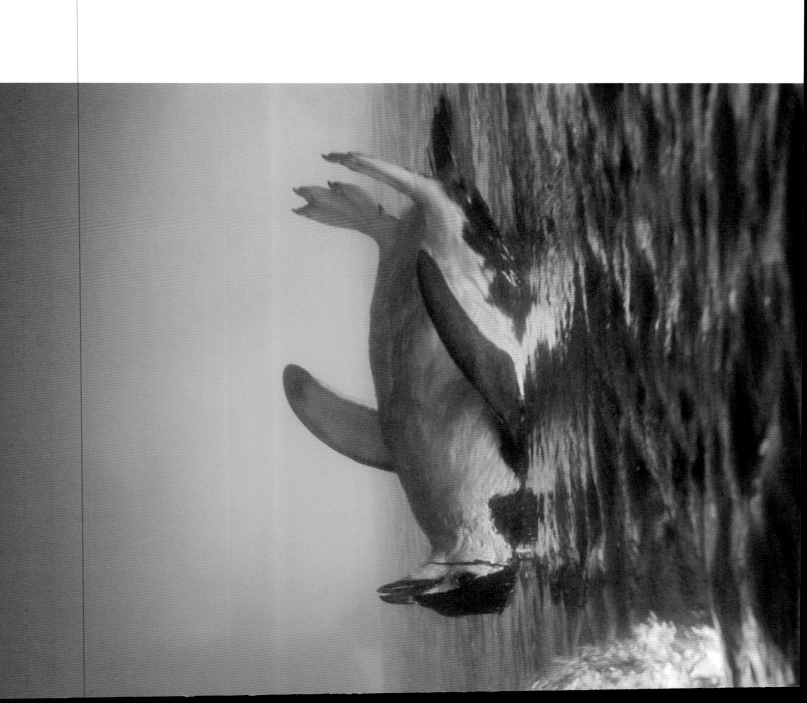

Frustrated that I continue to refuse her offerings, she blows streams of bubbles, Anvers Island.

178

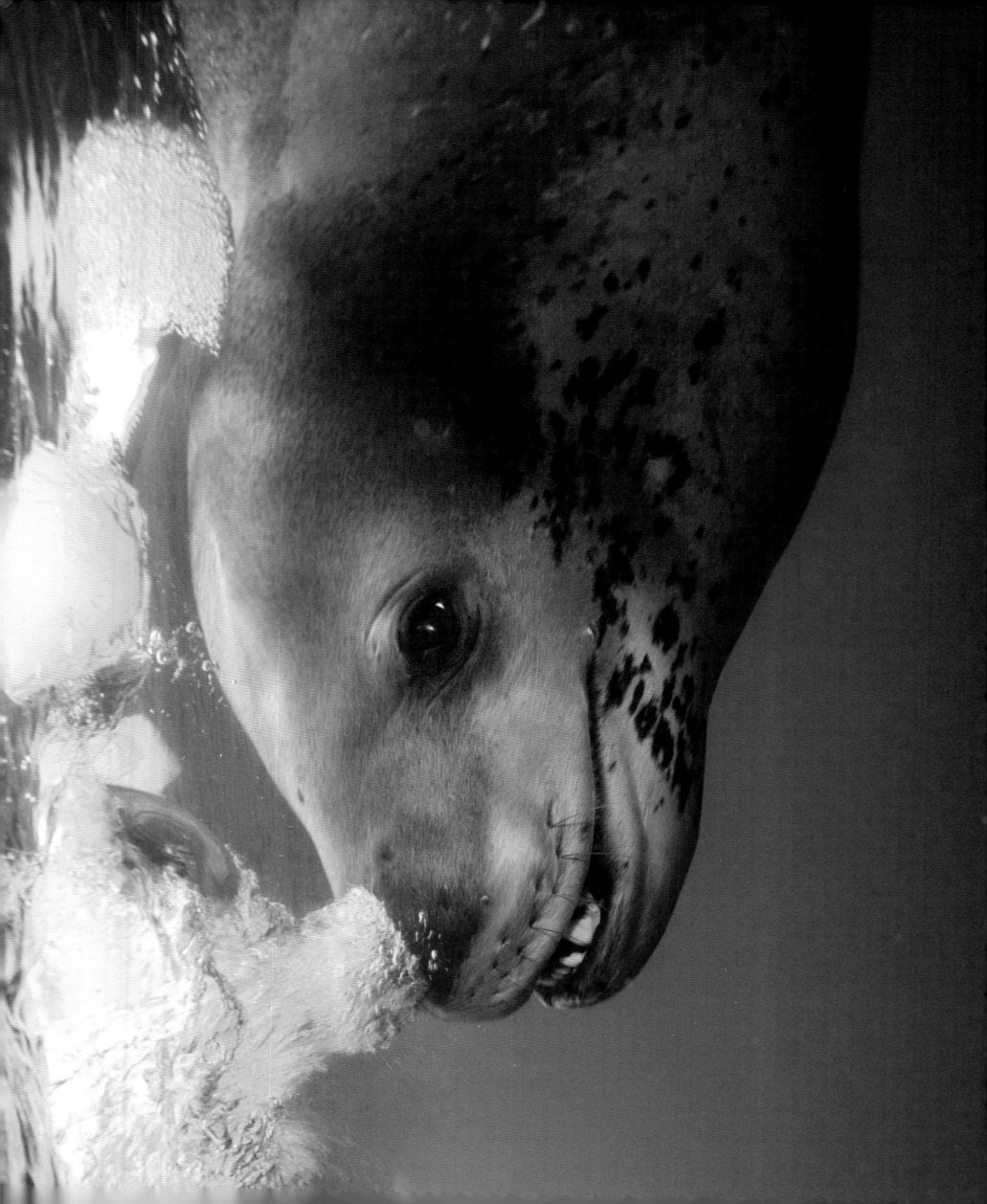

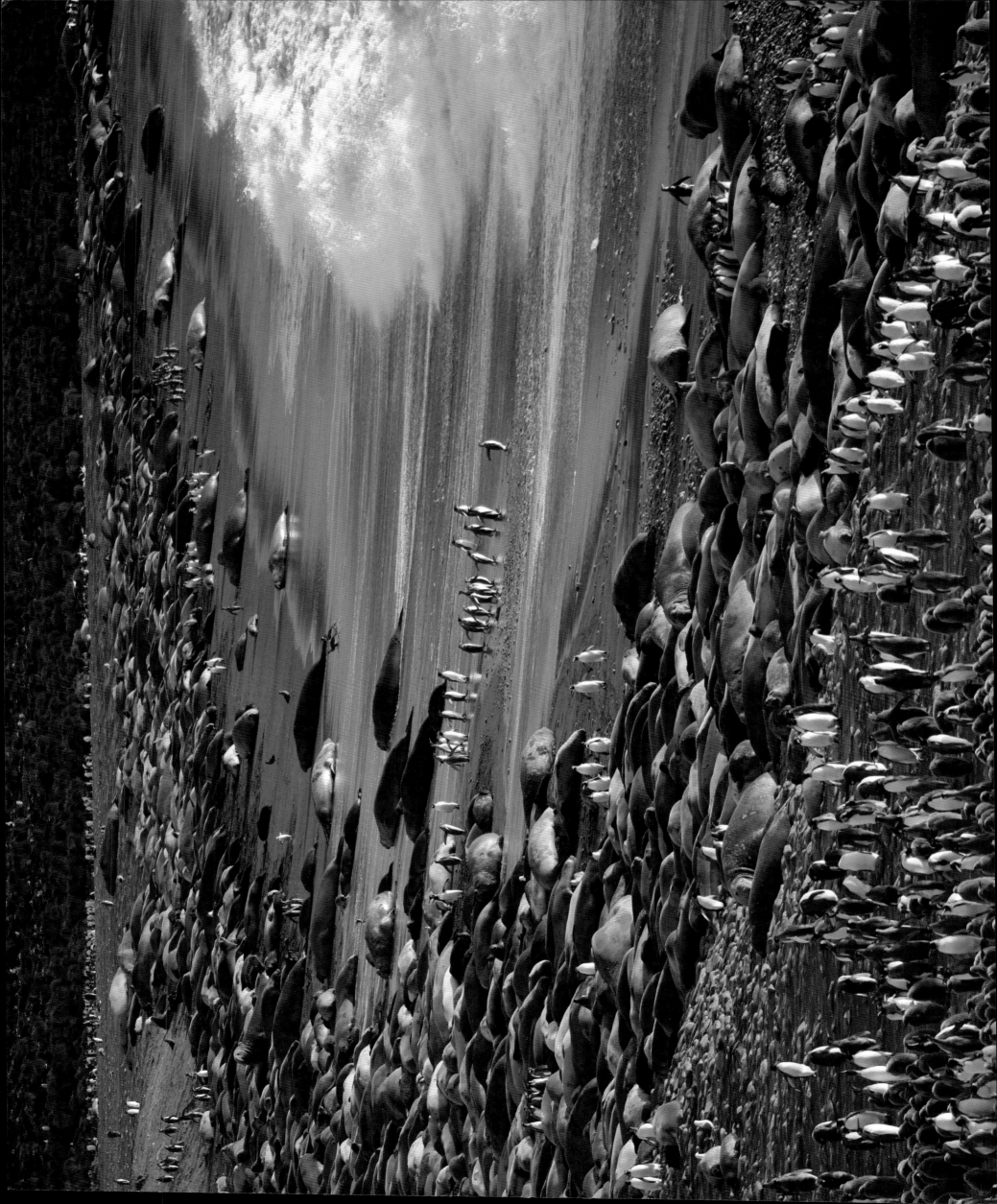

In late September and October the first of the large breeding elephant seal bulls arrive on one of the many beaches of South Georgia. This bull in Fortuna Bay rests in the surf zone after a lengthy migration. Arriving early is not always the best strategy for the bulls. By the time the breeding season peaks, many of the early arrivals will already be tired from defending their beach territory. If they lose too much weight, or become weak or injured, then they can easily be displaced by a stronger bull. They will then stay on the periphery of the herd, in the surf zone or higher up on the beach.

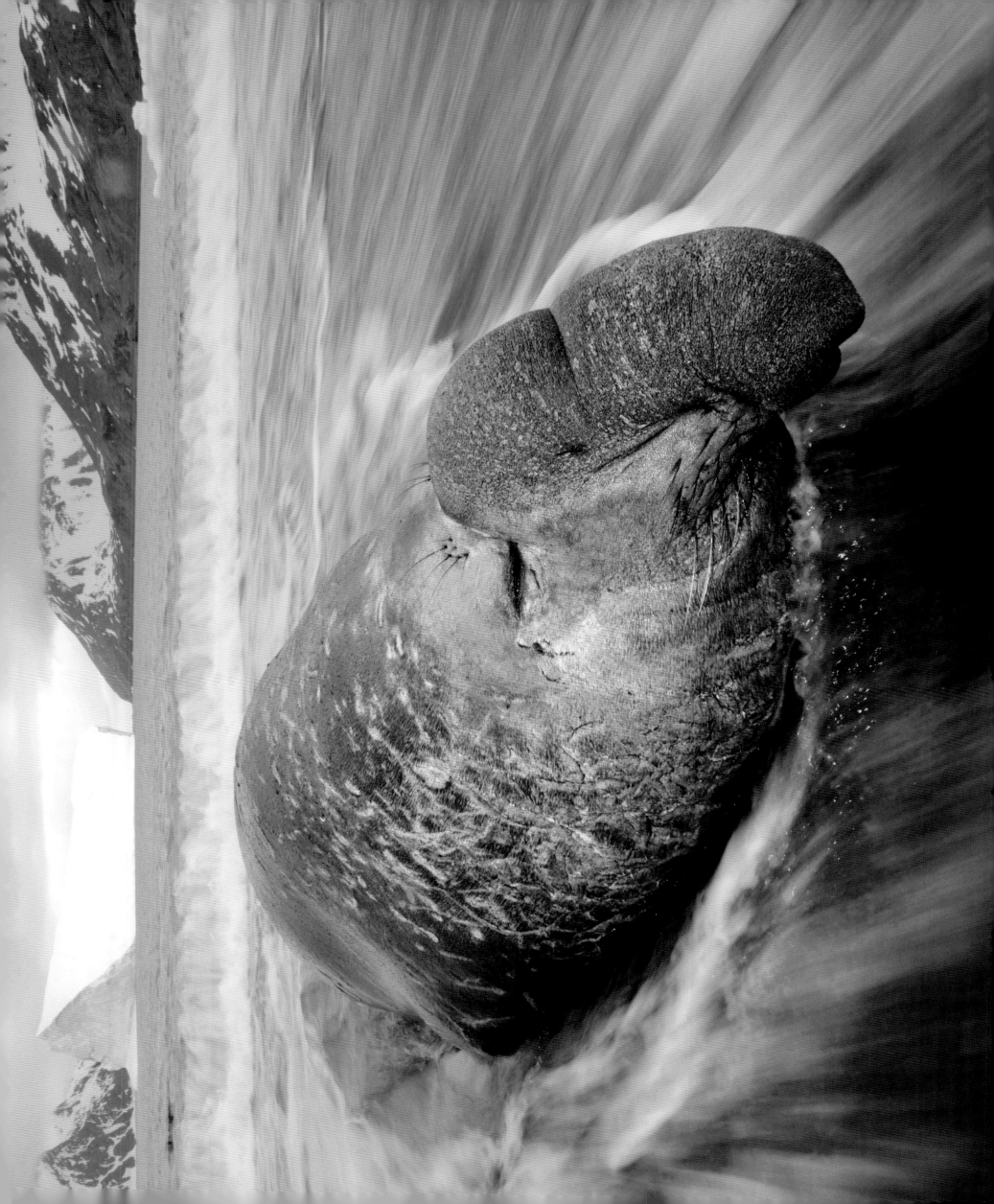

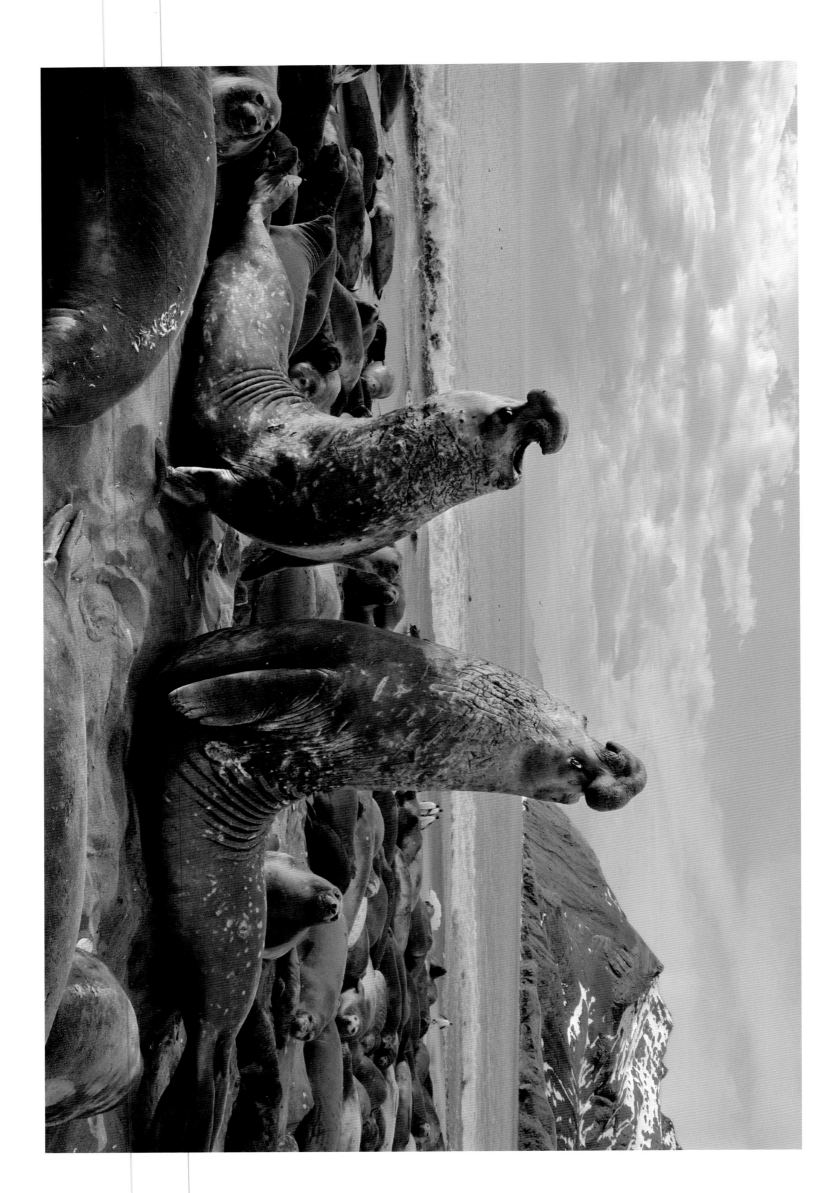

Elephant seal bulls in their prime battle for the right to breed, Saint Andrews Bay.
> A bull throws sand on its back to keep cool, Gold Harbour.

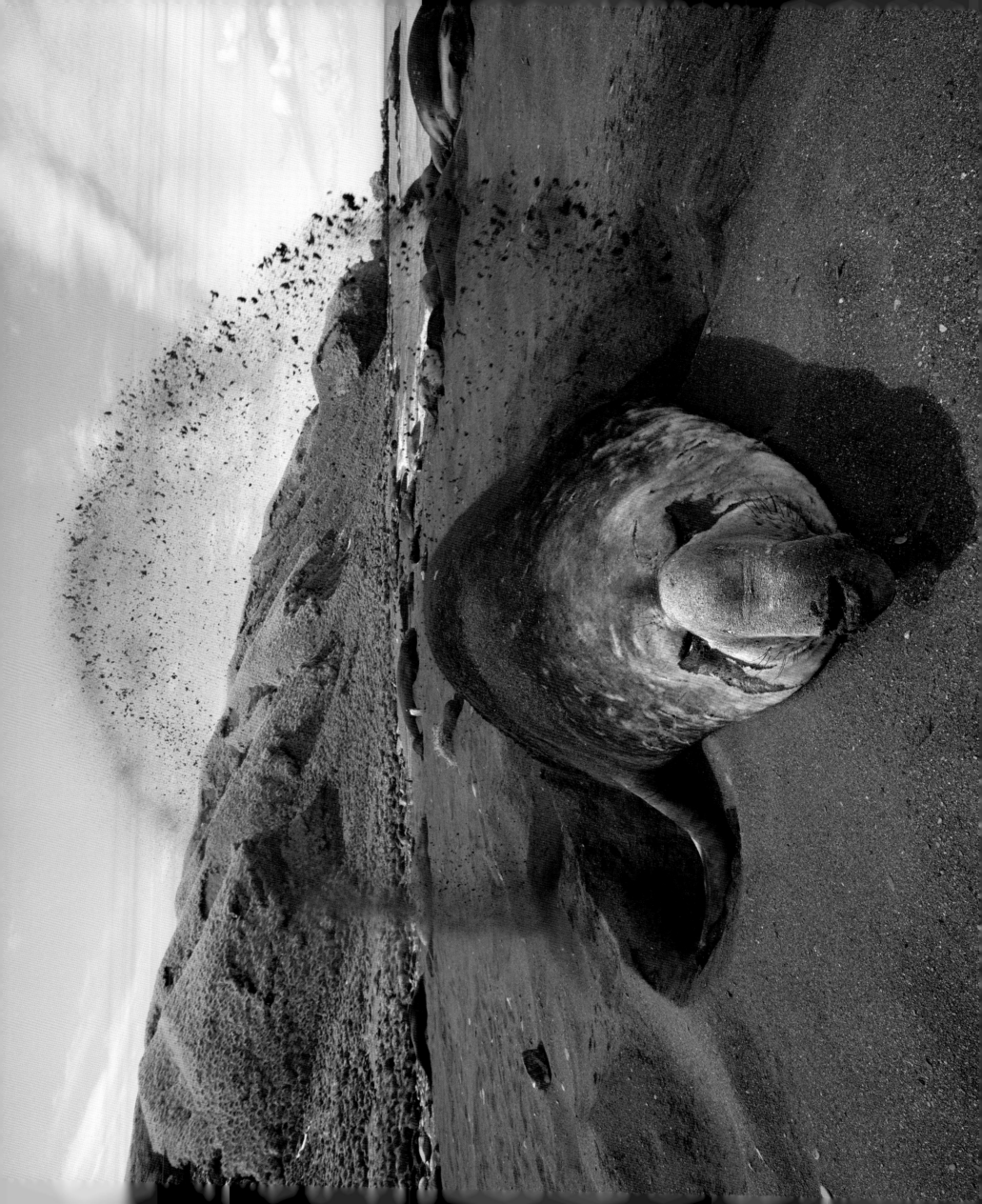

Young elephant seal bulls mock-battle in the shallows of Cooper Bay.

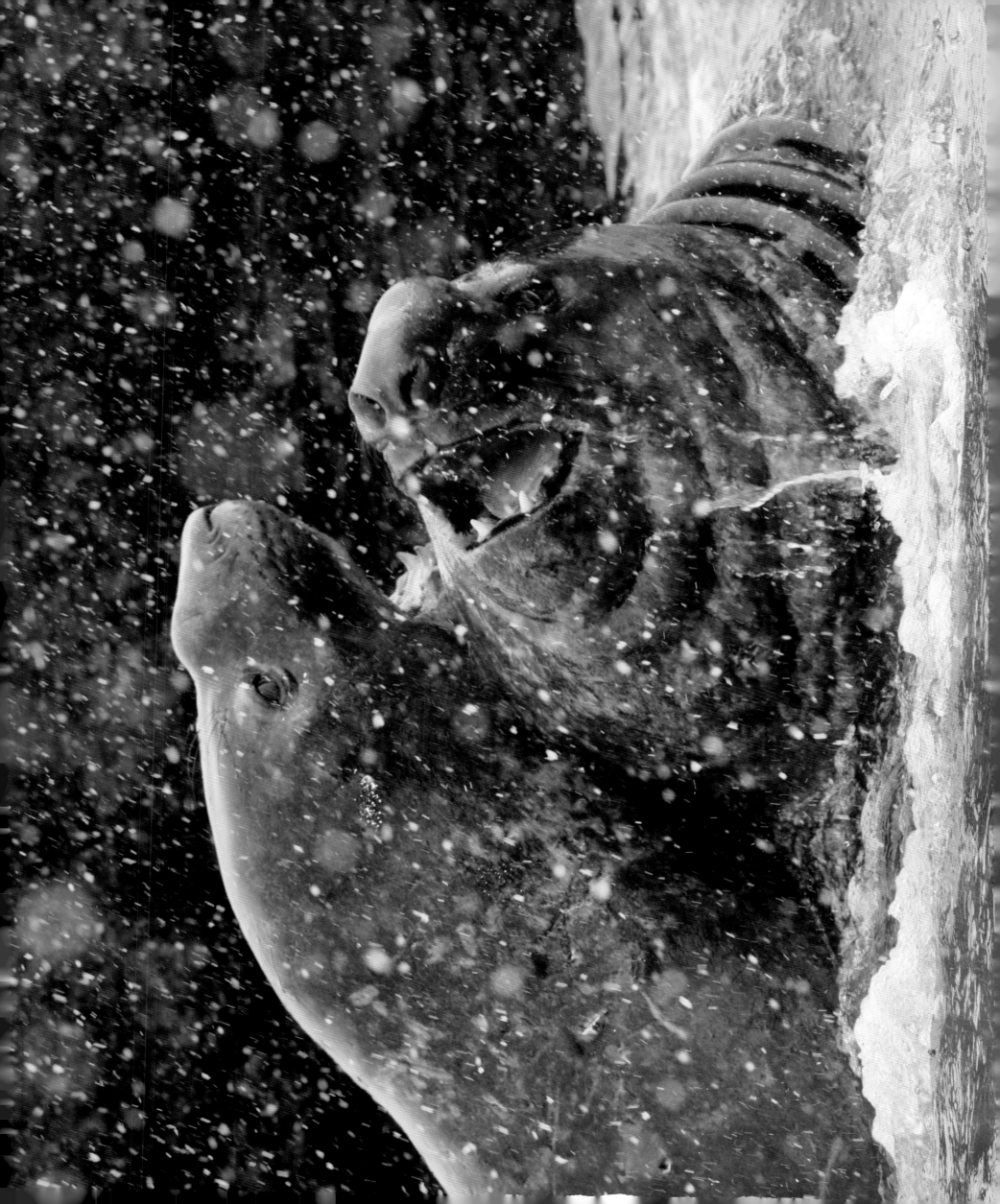

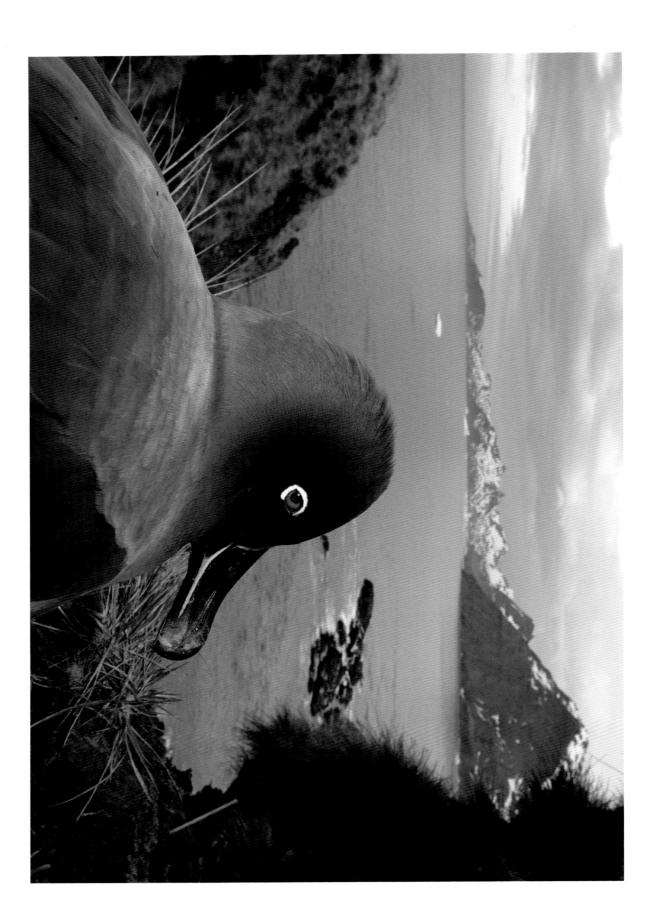

Nesting light sooty mantled albatross, Cold Harbour.

> The tussock grass–lined shore of South Georgia, Cooper Bay.

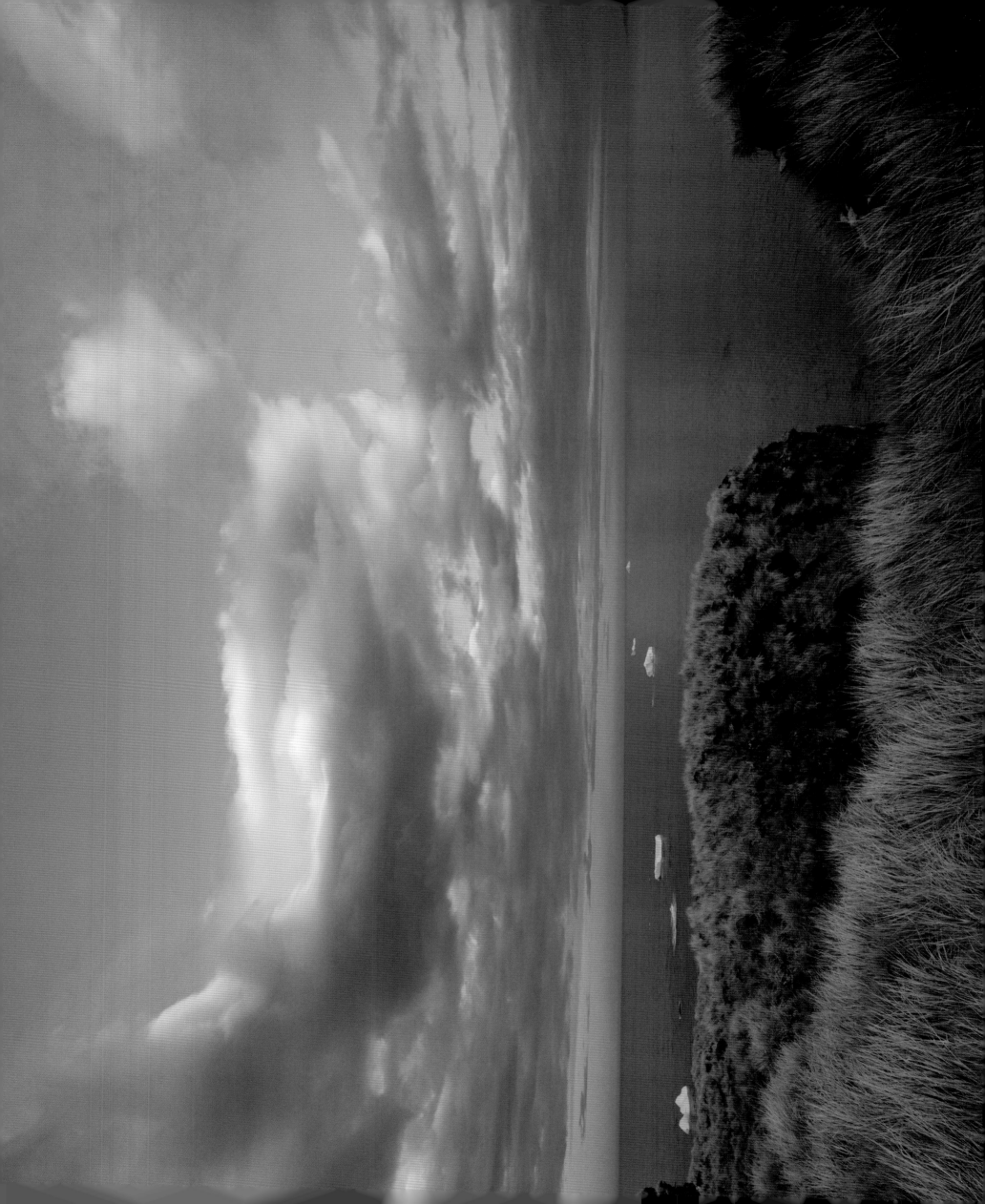

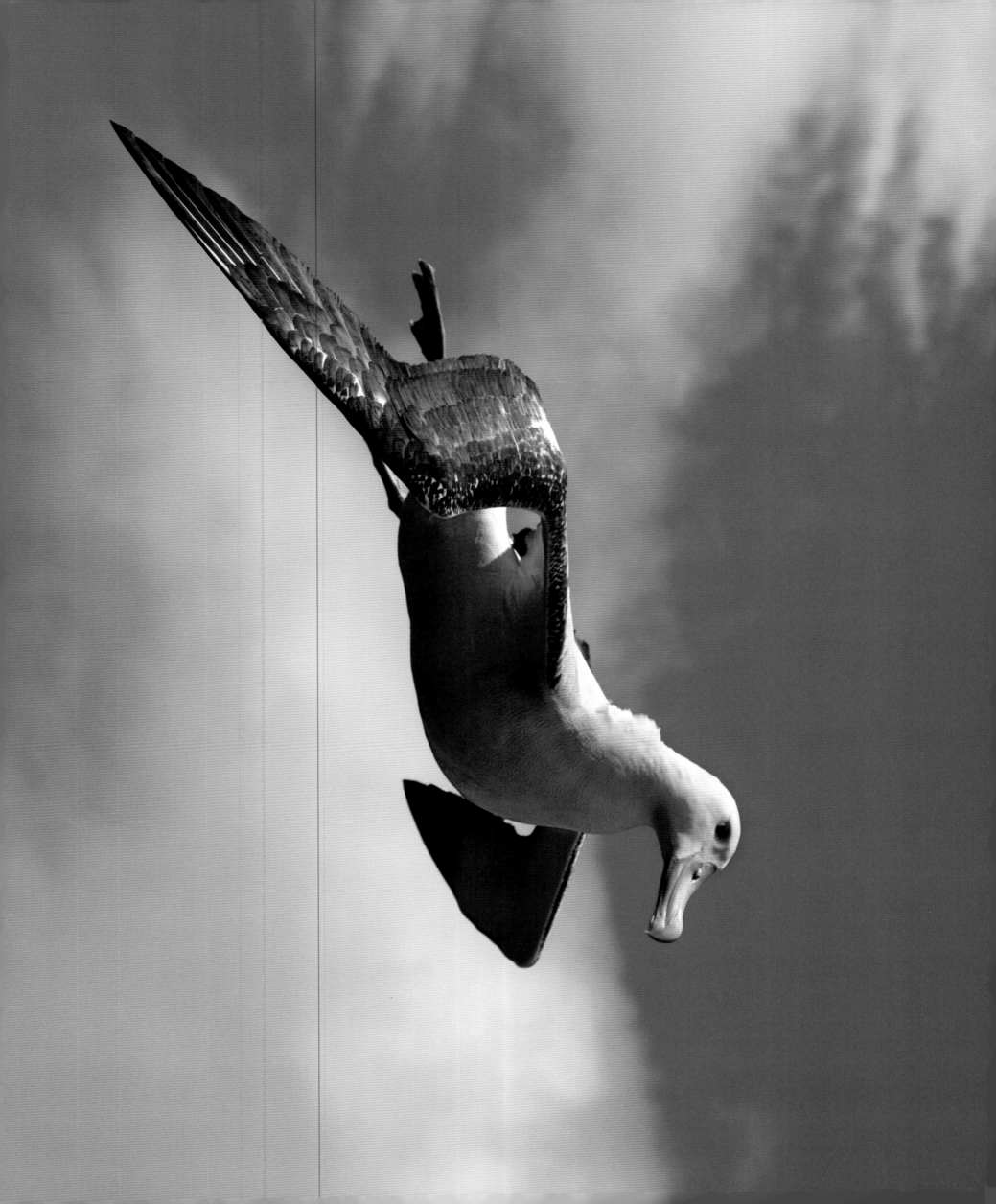

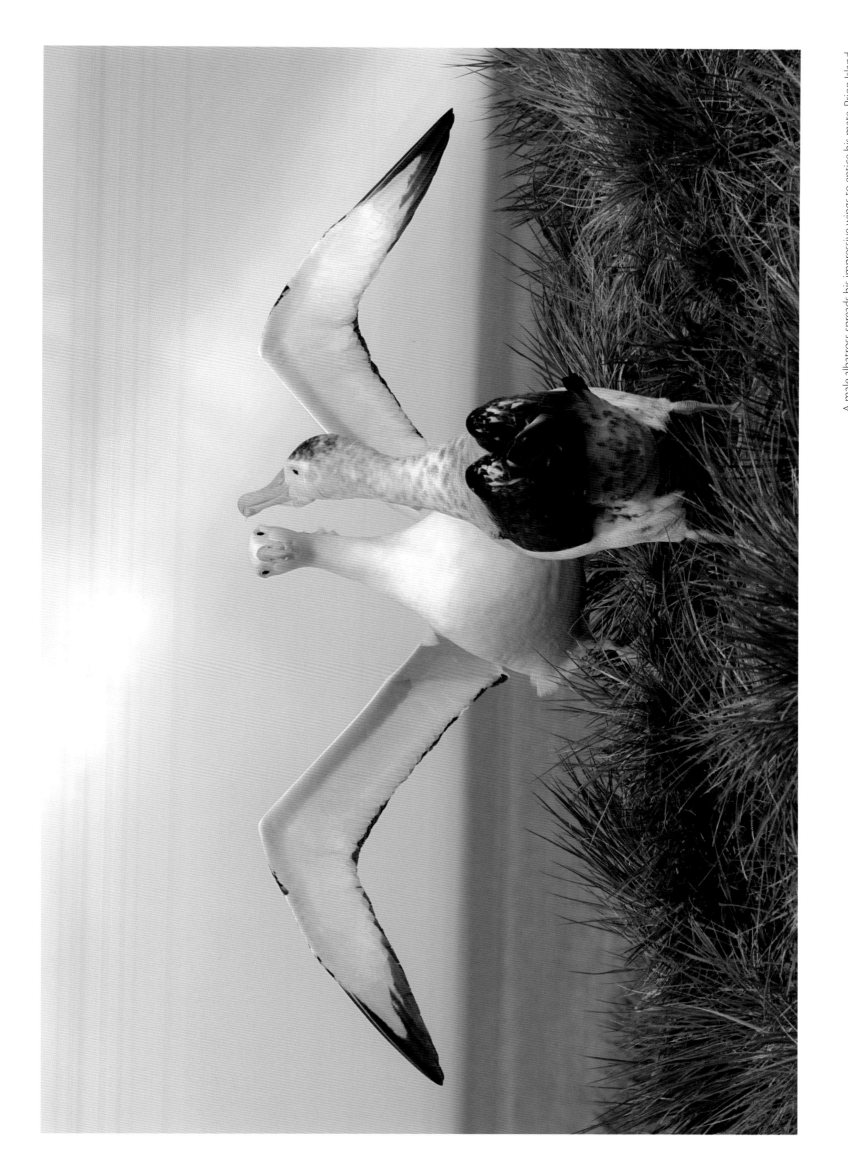

A male albatross spreads his impressive wings to entice his mate, Prion Island.
< A wandering albatross comes in for a landing on its 3-meter (10-foot) wingspan, Prion Island.

A large iceberg pales against the scale of South Georgia's towering peaks and immense weather systems. With 3,000-meter (10,000-foot) mountains barely looming under an approaching low-pressure system, South Georgia never let us forget that she can change without warning, and her rough weather can hit with incredible force. On four different occasions we experienced winds in excess of 102 knots (120 miles per hour). The lone iceberg, brilliant against the darkening sky and deceptively huge, is a reminder of the diminishing ice shelves on the Antarctic Peninsula. Icebergs drift across the southern ocean and become lodged against the shelves of South Georgia, where they slowly disintegrate.

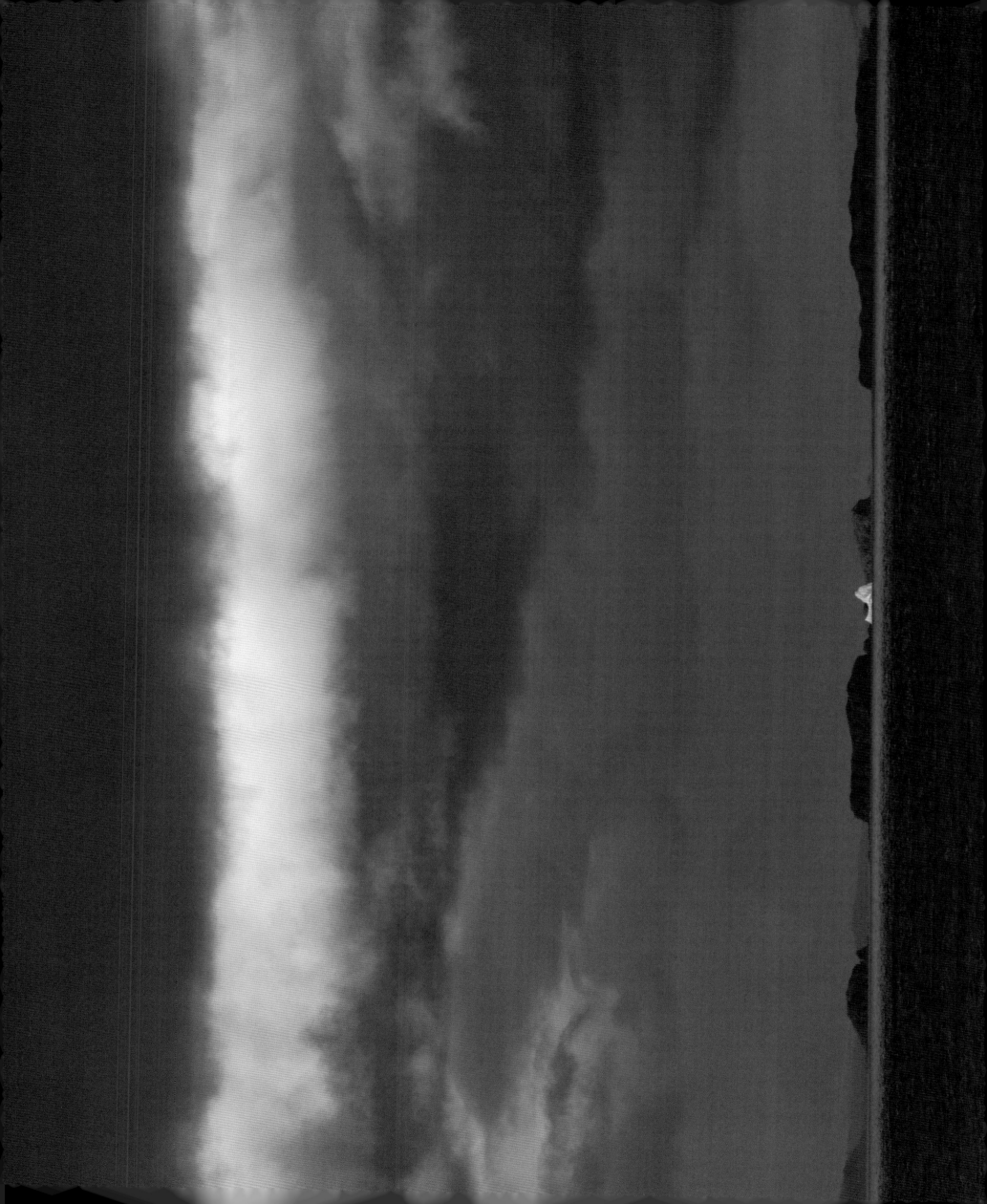

a snowmobile or possibly your life. After a couple of hours of this intense work, we were finally able to stop, catch our breath, and repitch our camp for the fourth time that week.

Your colleague Joel Sartore has said that you have taken the hardest path of anyone he knows toward becoming a photographer for National Geographic. Can you give us an example?
By my third year of university I had been severely bitten by the photography bug. In order to save money for my first underwater camera, I took a summer construction job in Yellowknife, Northwest Territories. I announced that I intended to work 70 days straight, 14 hours a day, leaving just enough time to buy my dream underwater camera and get back to British Columbia before classes started. At the end of the first day on the job, my hands seized up after smashing ancient bedrock with a sledgehammer for 14 hours. Because the dynamite crew had failed to blast deep enough, it was cheaper for us to chip rock for two weeks than to bring in the blast crew again.

On top of that job, I worked a two-hour night shift checking and refueling machinery. I was eventually promoted and given the illustrious title of pipe layer, which meant I got to crawl around in a muddy ditch attaching 180 kilogram (400 pound) lengths of pipe together. On several occasions, I had to walk around in raw sewage as I tried to make those connections. Dangerous and disgusting work it was, but as I worked out my 70 days in the ditches, the dream of holding that orange camera underwater burned bright.

I returned to British Columbia with my summer earnings and purchased the camera, lenses, and underwater strobes. I set the camera on my shelf and admired it proudly, reluctant to take it on its first dive. Finally, I gathered my courage, loaded the film, and set off. As I carefully slipped into the water, I noticed bubbles streaming from the Nikonos V body and 20mm/2.8 lens. My first thought was that this must be normal, until I resurfaced and drained two cups of water out of the camera. I found out later that a friend had been goofing around with the o-rings while I was prepping the camera and had set the main body ring on a different shelf.

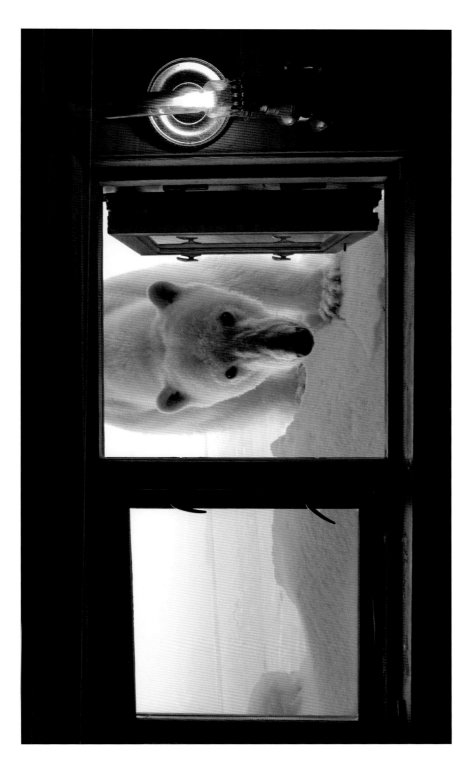

Curious female polar bear eyeing life inside a cabin, East Svalbard.

This was to be the first of many setbacks in my career as a photographer. It was a big blow, but an important lesson in overcoming adversity. Once the camera was repaired, underwater photography became an obsession. My grades suffered for it, but as long as I maintained a passing average, they wouldn't kick me out of university and I could keep pretending I was a student.

Can you recount a career-defining moment?
My three-month solo expedition on the Horton River in 1994 was a life-changing experience. My goal was to live in isolation and try to capture unique photographs of Arctic wildlife, particularly the tundra wolf. There were hardships to endure, not least the mosquitoes, and my mood fluctuated between euphoria and despair. My quiet, peaceful life changed at three o'clock one morning when I went outside to relieve myself. As the large,

orange sun swept across the barrens, I stood there naked, staring at the same hills that I had been watching for weeks. But something was different; the hills were alive with movement. On my continuing journey toward complete insanity, I wondered what I was actually seeing. I ran back into the tent for my binoculars, and returned for a closer look. Thousands of Bluenose caribou were advancing toward me. With no time to get dressed, I put the 500mm lens on my tripod and crouched in the short willow bushes along the riverbank and waited. I trembled with excitement as the wise females in the herd led strings of caribou my way. Groups of tens, then dozens, then hundreds, began crossing the mighty Horton River in single file. The clicking of the hooves, the snorts and grunts, and the smell of wet caribou hair filled my every sense. Soon they had passed, and I was alone again, truly at peace and in love with life. As white-crowned sparrows sang around my

tent I realized my true role in life: to be an ambassador for these precious beasts.

What advice do you have for people who work in the cold, particularly underwater?

To me, working in the polar regions is powerful, beautiful, and unforgettable. But, if you allow yourself to get extremely cold—near hypothermic—it can become very dangerous. Also, you will likely be incapacitated to the point that you can no longer shoot photographs. Whether diving under the sea ice or standing on the surface in a blizzard, with a windchill of −70°C (−90°F), the human body is equally vulnerable to exposure. Experience has taught me to constantly evaluate how cold I am feeling. This is essential for preventing hypothermia.

For example, on a dive under the ice my fingertips will start to burn really badly after about 20 minutes. It feels as if someone is holding my hands against an open flame. Even though the pain is intense, it is not a sign to get out of the water because I can still feel my fingers. Then I get to a point where I really have to will my fingers to do anything. When I lose all feeling in my hands—to the point that I can't tell they are attached to my body—I need to start paying attention. The same thing happens with my toes and feet after about 30 minutes underwater. This is when I start to take notice, because my body is going through something called *blood shunting*. My body core temperature is starting to drop, and in response, my body takes the blood from my extremities and sends it to my head and major organs.

My head is also losing heat rapidly, because I wear a wet hood, and after about 40 minutes in the freezing water, I start to shiver really badly, as my body tries to keep warm. I feel cold all over, and at this point I have not felt my hands and feet for 10 to 20 minutes. After about 50 minutes, my legs begin to cramp, and I can no longer kick effectively, which puts me in the danger zone. I have to constantly stop and stretch out my calf and hamstring muscles. To complicate things, I get dehydrated underwater. When my legs are cramping, I can't feel my extremities, and the shivering begins to slow down, I know that I am approaching hypothermia and am very close to becoming incapacitated. Rarely do I stay under the ice long enough to reach this state, but I have learned to recognize these symptoms over the years from those times when I pushed myself too far.

My assistants are often super-fit guys who look like Olympic athletes, but they can usually only last half as long as I can underwater. This is partly because they have very little body fat and partly because of their pain threshold. It is so stunningly beautiful underwater that it becomes very easy for me to lose track of the pain and ignore the potentially lethal symptoms of hypothermia. It is almost as if the incredible marine life warms me when I am photographing. Whenever I run out of film or digital card and just sit there, I get much colder, much more quickly.

How do you take care of personal hygiene when the closest sink is 300 kilometers (200 miles) away?

(Laughing) Often you don't. On my solo expedition, I went for two months without bathing or brushing my teeth! When I am in a camp with other people, then I try to have an occasional snow bath with a bar of soap, and sometimes I heat up water. When you camp on the sea ice, your bathroom is out in the open, and you are at the mercy of the elements. I just use snow and soap to wash quickly. However, once, during a terrible blizzard, I got food poisoning and had to go out in the storm every hour for 48 hours. I was alone in camp and kept looking over my shoulder for polar bears during the whiteout. It was really awful.

What's your funniest, or most embarrassing, experience?

I was out on the sea ice with two legendary hunters from Arctic Bay. For some reason I was feeling frisky and told them that as kids we used to run out across small chunks of sea ice as far as we could get. One of them smiled at me and pointed toward a few pieces (each one about the size of a coffee table) floating at the ice edge. There was a Japanese camera crew filming, so I thought I would put on a real show for everyone. I started running across the first few chunks of ice but then missed my step and went into the ocean. Drenched with icy water, I pulled myself onto a larger chunk, and then had to run back across the small pieces to the floe edge. The elder was laughing so hard that he couldn't stand up. Fortunately, when the final story came out on Japanese television, that clip was not included.

Can you describe the process of envisioning a photograph?

Before I actually go out into the field, I need to envision the pictures I want to make. Otherwise once I arrive, it can feel chaotic, especially when there are many animals of different species and a lot of action; that makes it difficult for me to focus on any one thing. The other possibility is that the animals I want to photograph might not be there at all, in which case I really have to search to make a picture. To be able to handle either of these field situations, I have to prepare. I contact scientists, Inuit hunters, conservationists, and other photographers to find out as much as I can about my subject and the area. For example, the daring wildlife photographer Göran Ehlmé told me that when you first encounter leopard seals, they tend to make big open-mouth gestures with gaping jaws that span more than half a meter (over 2 feet). They'll move forward in this posture and nearly engulf your head in their mouth, which definitely achieves the purpose of intimidation. I thought what an incredible picture I could make if, instead of retreating or giving in to my fear, I could photograph the open-jawed charge of one of these seals.

To complete my visualization, I took a piece of paper and drew the exact angle of the teeth and their position as they would fill the frame. By the time I was actually on assignment and in the water near a huge female leopard seal, I felt that nothing she could do would surprise me. Armed with this level of familiarity, and knowing the exact picture I wanted to capture, I could allow my instincts to take over, and the shots just naturally worked.

They say that's the difference between a professional wildlife photographer and an amateur. Amateurs tend to follow the camera around, taking pictures to record a moment, and

they often get good results. But these images happen at the convenience of the photographer's schedule and equipment. Professionals, on the other hand, work at the convenience of the conditions. They may spend hours, weeks, or even years to make a picture that features a scene or an animal in a particular pose at the right time of day, in the desired setting, during a certain season, and with a particular set of lighting and weather conditions. As the famous whale photographer Flip Nicklin taught me, "Getting a picture in focus and properly exposed is not the end but just the beginning." For a picture to be great it needs another element, such as being moody, dramatic, having incredible lighting, or capturing some amazing behavior.

At times, I might shoot the same general scene photographed by an amateur, but it will be exactly what I've intended to capture, as opposed to the result of good luck. For example, I might decide to shoot animals on a beach under a full moon, with the tide half out, and the animals clustered in a certain way. When I make the picture, I try to shoot it just as I've envisioned it. That's not to say that I arrange anything in the frame; I don't. I don't have control over anything in the frame except timing. I have to make sure that I'm in the correct spot when the moment occurs and that I react quickly with the right equipment. This sometimes means waiting as long as a month to get the photograph right, as opposed to shooting the subject in whatever conditions I first encounter. It's very easy to take mediocre photographs, but for compelling images that have the power to transport people into the world you've experienced, the picture has to be memorable. That is why I often talk about making pictures and not simply taking them.

What are your primary considerations when you are photographing an animal for the first time?

I always prefer to get close to animals that demonstrate a complex social structure, which can be a testament to the species' intelligence. While swimming with walrus, narwhals, or leopard seals, for example, I know I have the opportunity to communicate through body language, just as these animals will try to communicate with me. I never want to appear fearful or act aggressively. It is this peaceful and gentle balance of mood and behavior that I strive to achieve, and when I do I find I am allowed entrance to their private realm.

In my first encounters with an animal, I move slowly, watch very carefully, and constantly analyze its behavior in response to my presence. This is not only for my own safety but also for the safety of the animal. If an animal were to attack and hurt me, the news would damage the reputation of that animal and cause people to fear it—the exact opposite of what I am trying to achieve. With careful preparation, I can show the animal in its best light, demonstrating its beauty, strength, and intelligence.

I'm self-taught, and have had had no formal training in photography. Part of my strategy was to study the quality of images that other photographers were making and then to go out and shoot stories that maintained that kind of quality throughout. When I was starting out in photography at the age of 26, animal game farms had just opened up everywhere. A person could go to a game farm and rent a cougar, a snow leopard, a grizzly bear, and a wolverine and pay $500 to photograph four species in a day. It could take months, perhaps a lifetime, to make intimate images of these animals in the wild.

I became very inspired to do exactly the opposite; the more photographers went toward game farm photography, the more I wanted to go to very remote places to photograph things that nobody else was photographing. I shoot the most intimate

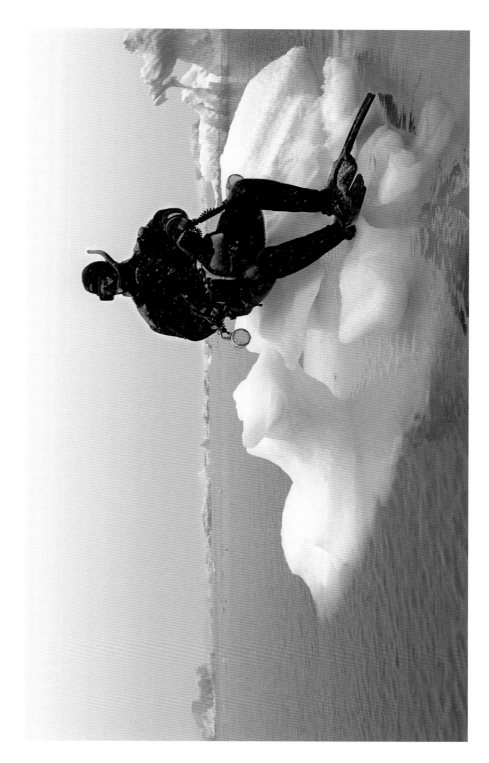

Waiting to be found by a curious leopard seal, Pleneau Island, Antarctica.

pictures of rarely seen subjects that I possibly can. I realize that if I really want people to care about polar species such as the polar bear, leopard seal, walrus, and narwhal, my images have to be wild and raw. To achieve that, I strongly feel that the images have to be taken in the species' natural setting. I want people to feel what it's like to be in the water, swimming three feet from a polar bear. I want them to experience what it's like to be offered a penguin as food by a leopard seal. Only then will they care about that habitat and that species. Two colleagues at National Geographic have nicknamed me the Underwater Street Photographer, because it's the street photographer who gets as close as possible to each subject, sometimes bringing the camera lens to within inches. Many wildlife photographers mainly use a long telephoto lens to shoot full-frame images. If I am using my 600mm lens, then I know I am not close enough. If I am on my belly, photographing an arctic fox for example, with a 17mm lens, then I know I am getting something good.

I also concluded that if I was standing shoulder to shoulder with a bunch of people on a road in Alaska and we were all photographing the same moose, I was not doing nature any service as a journalist. But if I was alone in a remote area, or under the ice in a challenging situation, and pushing myself to get something that I really believed in, then I felt that I was doing what I was meant to do. My aim has always been to bring previously unseen images of our beautiful world to the readers of National Geographic and to people all over the world.

How did you get your first National Geographic assignment? Have you had a mentor, and do you mentor others?

By the time I was 28, I had published my first book, and my photographs had been published in *Life, Natural History, Terre Sauvage,* and *Time,* among other outlets. But I realized that this work represented just a scattering of stock photos, and I knew I had a difficult road ahead if it was going to achieve my dream of photographing stories for *National Geographic.* It was very hard to get in; *National Geographic* by no means opened up their doors to me. I sent in proposals and ideas for years, and they were always turned down. So it was exciting to finally meet *National Geographic* photographer Flip Nicklin, who became my first mentor. My time with him was very valuable in shaping my ability to tell photographic stories. Then Flip encouraged me to work on a story that he and Joel Sartore were photographing for the magazine on Clayoquot Sound, on the Pacific coast of Vancouver Island. They allowed me to photograph spawning salmon and Steller sea lions. Fortunately, two images from that opportunity were published, and that led to my first assignment for the magazine, a story about Atlantic salmon.

I have mentored a lot of young photographers, because I know what it's like to have a dream and be unsure of what path to take. Their love of photography leads some of them to journalism school, but that's not the answer for everyone. Everyone has their own path.

What's the most difficult thing about being a photographer working in polar environments?

Every story has its challenges. I'm usually working in extreme isolation in very harsh environments where weather conditions can quickly become dangerous. The types of animals I'm photographing also present their own challenges. Even when I've been well prepared, careful, and lucky, I have found myself in life-threatening situations. I'm often walking a fine line, and I get into trouble when I step across it and push the limits to get unique images. For my work in polar environments, it's very important to know ice really well. I have to know whether the surface is solid ice, water on top of ice, or just snow on top of water, because getting to the right locations usually involves traveling great distances across the ice. If your snowmobile falls through, you could lose your machine, or even die. Even if you manage to get out of the water, you're soaking wet at temperatures well below freezing, so you have a very limited amount of time before you get hypothermia. One day as I was crossing the sea ice with my friend and guide Karl Erik Wilhelmsen, his snowmobile broke through the sea ice. Luckily he had enough speed and we both raced, skimming over the floating chunks of ice. Even though it was a serious situation at the time, we laughed about it later.

While on an assignment in Svalbard, Karl Erik I and traveled over 2,000 kilometers (1,200 miles) on snowmobiles, crossing sea ice in various conditions, including very thin ice. He was a great guide, very experienced and extremely passionate about a land he loved so much. We often worked 24 hours straight under the endless spring sunlight in search of polar bears. Near the end of our project, we got caught in a blizzard, with the wind blowing so hard we could hardly stand up. The snow was just drifting everywhere, and we couldn't see anything. We tried to find land, so we could get off of the sea ice and head back to our camp. We were almost to where the sea ice met solid land when we both got bogged down in deep snow that was saturated with water. We were not sure how thick the ice was, but we suspected that it was very thin. The wet snow cover was maybe two feet deep, and it was so slushy that we couldn't get the snowmobiles with our heavy loads of gear unstuck and onto the land. We had to remove all but the lightest gear from our snowmobiles, and then make multiple trips to get our gear the final 300 meters (1,000 feet) to land. It took us two or three hours in this blizzard, and we were sweaty and exhausted, but still, we kept laughing, because we had enjoyed the challenge and the risk of being at the mercy of Mother Nature. When I said goodbye to Karl Erik at the end of that trip, we made plans to meet again in Svalbard that summer. Only four days after I got home, I received a call from a friend who told me that Karl Erik had been out on the sea ice with some friends, and they had gone through. He was the only member of the group who did not survive. I was absolutely crushed and in complete disbelief. Karl Erik was competent, careful, and knowledgeable, and a brief moment of bad luck caused him to be claimed by the land that he loved so dearly. The greatest tragedy in this kind of work is to lose a friend, someone you've worked with closely and whom you care about.

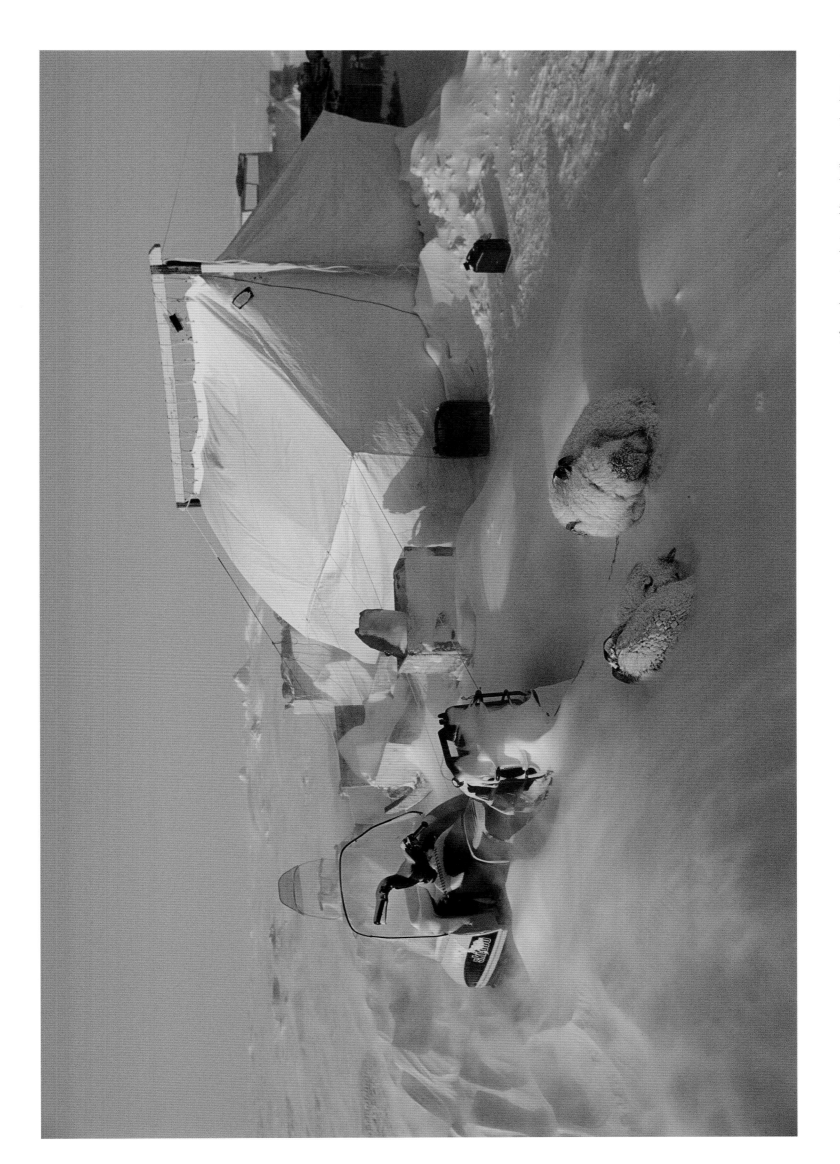

Life on the sea ice during a blizzard, Ellesmere Island, Nunavut.

Following pages: Blending in with the surroundings during a whiteout, East Svalbard.

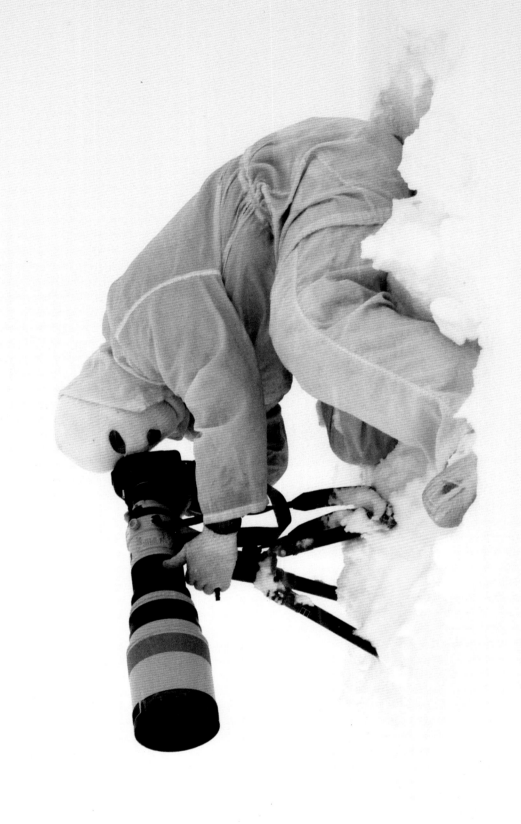

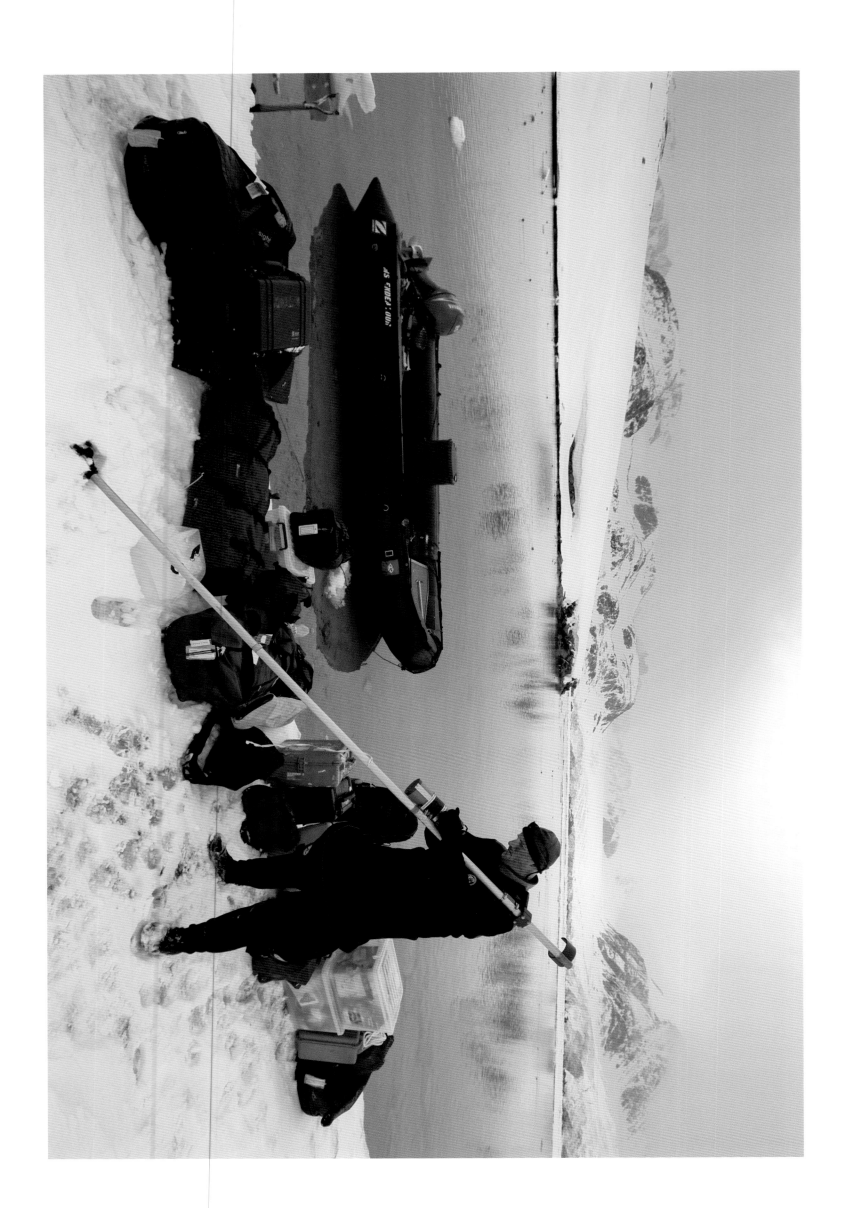

635 kilograms (1,400 pounds) of equipment, a Zodiac, and some freeze-dried food equals six weeks in paradise, Northwest Svalbard.

Gear List

I shoot both above and below water, so I need a very broad range of equipment, which means that I likely have more equipment than any other natural history photographer on the planet. In addition to my camera gear, I have multiple underwater camera housings, scuba equipment, rebreathers for specialty bubbleless diving, underwater remote cameras, an inflatable kayak, a Zodiac inflatable boat, computers, generators to run the computers, and spare parts kits for everything. The list goes on. I even purchased my own ultralight airplane from which to shoot aerials in the Arctic. I usually travel with 14 to 20 cases and hockey duffel bags weighing between 60 and 70 pounds each. Airlines really dislike me when I show up with three or four luggage carts all linked together with rope. Getting to and from location with all of this gear is often the worst and hardest part of my assignments, but it is worth having the right tools for the shoot once in the field.

My current camera equipment includes:

2 21-megapixel camera bodies

1 10-megapixel camera body

2 8-megapixel camera bodies for the 10 frames per second

3 underwater housings

6 underwater strobes (flashes) and multiple strobe arms

Wide-angle and macro lenses: 15mm/2.8 fisheye, 20mm/2.8, 24mm/2.8, 16-35mm/2.8 LII, 17-40mm/4.0, 24-70mm/2.8, 24-105mm/4.0, 50mm/2.5, and 100mm/2.8 macro

Mid-range lenses: 70-200mm image stabilized (IS), 100-400 (IS)

Telephoto lenses: 500mm/4.0 (IS), 600mm/4.0 (IS), with 1.4x and 2x converters and extension tubes

Multiple 580 EX flashes

3 carbon-fiber and aluminum tripods

Wimberley and Ballheads for tripods

Other equipment:

2-seater ultralight airplane

Inflatable kayak

50-watt HID lights

3 sets of cold-water diving regulators

3 frameless diving masks

2 pairs of extra large split fins

Mixed bag of scuba diving equipment

Diving rebreather, Sofnolime, and pure medical oxygen

2 waterproof dry suits

Ice screws, ropes, and other gear for ice diving

Multiple backpacks, duffle bags, hockey bags, and 10 hard cases

2 Gore-Tex jackets and pants, fleece and more fleece

700 fill down jacket with an excellent hood

700 fill down windproof pants

U.S. military bunny boots

Canadian military whites for shooting in the snow

6 pairs of windproof gloves and outer mittens

Balaclavas (full face masks), hats, and neck tubes

2 2-person sleeping tents

1 4-person tent for extra gear

8' x 10' wall cook tent

2 cooking stoves and fuel

Coffeemaker and 5 pounds of coffee (I don't drink coffee)

Inflatable camping pads

800 fill down sleeping bag good for -45°C (-49°F)

100 pounds of dried food

Snacks: dried fruit, nuts, and chocolate

Pots, pans, utensils, matches, and windproof lighters

Big pot for melting snow/ice for drinking water

Hunting knives and several leathermen pliers

Iridium satellite phone

Global Positioning System

12-gauge Defender shotgun and bear bangers

Spare parts and tool kits for everything

2 laptop computers and 6 500GB hard drives

Gas-efficient generator to power computers and hard drives

Books about explorers so I don't ever think that I have it rough

iPod full of Bruce Springsteen and Johnny Cash

Zinc and SPF 60 sunblock for life on the ice

Acknowledgments

This book is a tribute to the animals, large and small, that inhabit the ends of the Earth. The Arctic and Antarctica are among the most remote and challenging places on the planet to photograph, but the arduous task of working there was both fulfilling and enlightening because of the incredible encounters I had with the creatures and the wonderful support of many people.

The photographs collected here are a record of my ongoing journey in the polar regions. I may have been the one behind the camera, but I was fortunate to have many inspiring fellow travelers along the way, not least the team that carried this book to fruition: Jane Menyawi, Jeremy Eberts, and Stacy Gold. We came close to getting lost in the blizzard a few times, but we are a unified force in pressure situations!

Jane, thank you for the sensitivity you brought to the selection of images, and for putting up with my frequent absences when I was away on assignments. Your leadership and steadfast commitment held this project together. A special thank you to Carl Mehler for creating the beautiful maps, and to Susan Straight and Susan Hannan for editing the text. To Neal Edwards, who masterfully prepared the color of the RAW images for this book. Thanks also to Leah Bendavid-Val, John Q. Griffin, and Nina Hoffman for ongoing support.

Though credited as the designer of this book, Jeremy didn't limit himself to that role. I have valued his patience, guidance, and friendship, and his contribution to the photography selection and text editing. Thank you for going so far above and beyond on this project.

Stacy, my best pal and representative at the National Geographic Image Collection, gave unconditionally to this project. Thank you,

Stacy, and also your family, Iain, Emma, and Ailey, for giving me a home away from home during my visits to Washington, D.C.

Jeremy's brother, Jake Eberts, conceived the idea of this book during an expedition in the high Arctic several years ago. Thank you, Jake, for your encouragement and belief.

To Kate Barnes who so warmly and generously allowed us to use the quote from her father, Henry Beston. It is the most beautiful quote I have ever read.

The vast majority of the pictures in this book are a result of the incredible assignments, support, and belief invested in me by the editors of National Geographic magazine. Thank you so much, Kathy Moran, for your friendship and guidance through the publication process at National Geographic magazine on so many projects over the past ten years. I am also deeply grateful to Jenna Pirog, Elizabeth Krist, Ken Geiger, David Griffin, and Chris Johns for their encouragement and patience as I worked through my remote and challenging assignments. To Tom Quinn for his patience and for always booking me the right flights.

I am indebted to the National Geographic photo engineers, who continue to blow my mind with their creations to help us get new and innovative images in the field: Dave Mathews, Joe Stancampiano, Walter Boggs, Kenji Yamaguchi, and Keith Moorehead.

An unquantifiable thank you to my wonderful guides for their strength and for sharing their lifetime of knowledge and skill while in the field: Andrew Taqtu, Danny Taqtu, Roland Taqtu, Dexter Koonoo, Adam Qanatsiaq, Gideon Qaunaq, Samson Ejangiaq, Pakak Qammaniq, Seeglook Akeeagook, and Olayuk Niqatarvik.

In grateful memory of my friends Karl Erik Wilhelmsen, who tragically passed away when his snowmobile went through the sea

ice in Svalbard, and Timur Qamukaq, who suffered the same fate near Baffin Island. Both men were claimed by a land they loved and respected. I will never forget the laughter and the priceless experiences we shared on our travels together.

A huge thanks to Shaun Powell and Jed Weingarten, who stood by my side during any conceivable weather and some inconceivable risks, and to Brad Parker, for introducing me to the bowhead whales and walruses of Foxe Basin; to my high school friend Brian Knutsen, who came all of the way from Sri Lanka to safely and skillfully fly our ultralight airplane around Baffin Island; to Anne Bordeleau, of Diamondex, for so generously getting our little plane to Arctic Bay, Nunavut; to Mike Gill for sharing his wealth of knowledge about the struggling polar regions; and to my pal Göran Ehlmé—the "Swedish Cooler"—who guided me through the story of my dreams with his friends the leopard seals and who kept me warm under the polar ice by providing me with his award-winning dry suits manufactured by Waterproof.

Thanks also to Gilles Rigaud for his sailing skills across the Drake Passage and for regaling us with tales of his life at sea; to Alain and Claudine Caradec for using their lifetime of skills sailing us to Antarctica and back on several occasions aboard their sailboat, Kotick.

I owe particular thanks to several friends, the hardworking biologists who allowed me to tag along on their far-reaching expeditions: Kristin Laidre, Jack Orr, Kerry Finley, and Mitch Taylor, and to my mentors and friends Flip Nicklin and Joel Sartore, for continuous and selfless support over the years. This journey would not have happened without you.

For their support and encouragement throughout my life, I owe a special debt of gratitude to my family: Louise Roy, David and Ronda Nicklen, Aaron Nicklen, Mark Stainer, and Barbara and Fred Hartley. A special thanks to my mother, Louise, and my brother, Aaron, for proofreading the whole manuscript for this book, and for keeping me real. Dad, thanks for always being my phone-a-friend mechanic, while we struggled to keep our engines running in the field.

My thanks to Cristina Mittermeier and the International League of Conservation Photographers for continuing to inspire awareness of the diminishing habitats on this planet; to Sven-Olaf Lindblad, Captain Leif Skog, and Trey Byus of Lindblad Expeditions; and to Scott Kish and Jim Bullard of the National Geographic Society for their practical support during my expeditions to Svalbard, Norway, and South Georgia, Antarctica. The Svalbard story would not have been possible without your support.

And most of all, I am thankful for Lyn, who allows me to pursue my selfish and time-consuming mission of trying to protect the polar regions, never complaining about my long absences and always smiling when I return home. I would have given up on this dream a long time ago if it hadn't been for your support. Finally, I acknowledge my loyal dog Bo for showing me the true ways of being sleek and stealthy in the wildlife kingdom.